The Ted Kautzky Pencil Book

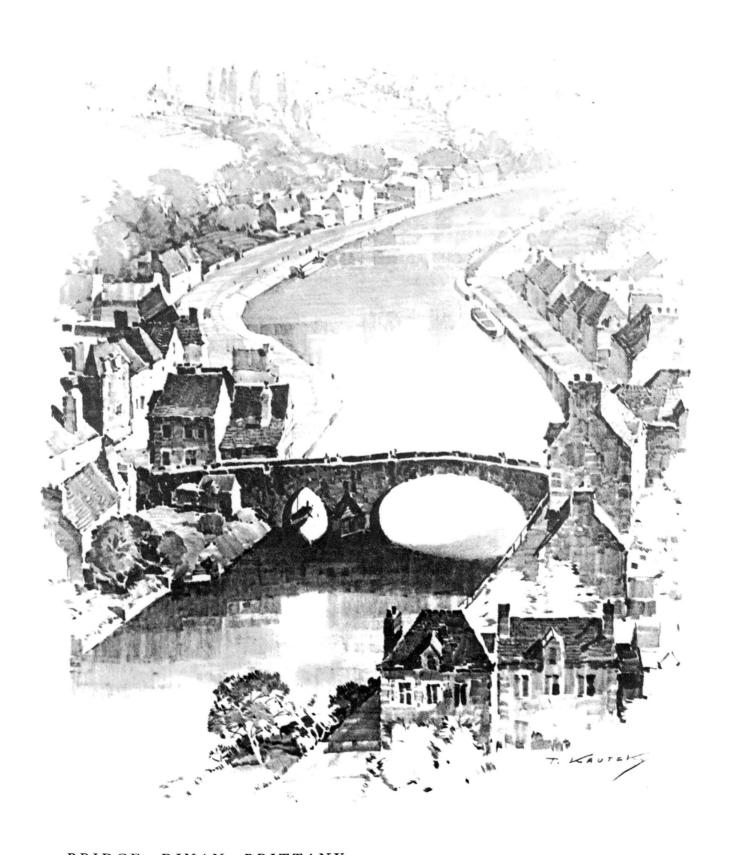

BRIDGE, DINAN, BRITTANY

The Ted Kautzky Pencil Book

Combined Edition

including PENCIL BROADSIDES, PENCIL PICTURES, and a portfolio of drawings

Copyright © 1979, 1947, 1940, 1920 by Litton Educational Publishing, Inc. Library of Congress Catalog Card Number 78-32126 ISBN 0-442-21575-4 cloth

13BN 0-442-21373-4 Cloth

ISBN 0-442-21576-2 paper

All rights reserved. No part of this work covered by the copyright hereon may be reproduced or used in any form or by any means — graphic, electronic, or mechanical, including photocopying, recording, taping, or information storage and retrieval systems — without written permission of the publisher.

Printed in the United States of America

Published in 1979 by Van Nostrand Reinhold Company A division of Litton Educational Publishing, Inc. 135 West 50th Street, New York, NY 10020, U.S.A.

Van Nostrand Reinhold Limited 1410 Birchmount Road

Scarborough, Ontario MIP 2E7, Canada

Van Nostrand Reinhold Australia Pty. Ltd. 17 Queen Street

Mitcham, Victoria 3132, Australia

Van Nostrand Reinhold Company Limited Molly Millars Lane Wokingham, Berkshire, England

16 15 14 13 12 11 10 9 8 7 6 5 4 3 2 1

Library of Congress Cataloging in Publication Data

Kautzky, Theodore, 1896-1953.

The Ted Kautzky Pencil Book.

Includes material originally published in the author's Pencil Broadsides and Pencil Pictures.

1. Pencil drawing — Technique. 1. Title. NC890.K34 1979 741.2'4 78-32126

ISBN 0-442-21575-4

ISBN 0-442-21576-2 pbk.

Publisher's Note

The late Theodore Kautzky was a master of pencil drawing. For years his two books, *Pencil Pictures* and *Pencil Broadsides* have been favorites of professional and amateur artists alike. This edition combines all the drawings, sketches, diagrams and text of the two previous books, plus several additional subjects into one comprehensive volume. Included are the techniques, subjects, attitudes and approaches that made Kautzky a unique artist and teacher.

CONTENTS

		PUBLISH INTRODU		
PART	Ι			
		LESSON	1	1 (
		LESSON	2	12
		LESSON	3	1 4
		LESSON	4	16
		LESSON	5	18
		LESSON	6	2(
		LESSON	7	22
		LESSON	8	24
		LESSON	9	26
		LESSON	10	28
		LESSON	11	3(
		LESSON	12	32
PART	ΙI			
		DDELIMI	NARY THOUGHTS	34
				36
		PICTURE SYNTHESIS VALUE ARRANGEMENT PLANNING A PICTURE SEACOAST REFLECTIONS THE FISHING PORT		38
				40
				43
				46
		THE USE OF CONTRAST		49
		COMPELLING THE EYE		52
			LAGE SCENE	5 5
		THE CHANGING SUN		5 8
		THE WIN	61	
		THE FARM GROUP IN ROLLING COUNTRY		64
				67
		THE HIL		70
		IN THE F		73
			IN SCENERY	76
			TY PEAKS	79
PART	ΙΙ	I		
		PORTFOL	JO OF DRAWINGS	83

INTRODUCTION

Like every other artist, I have been asked by very many lay persons, draftsmen, students, and amateurs to tell them how to go about making attractive pictures. Most of my questioners already know something about drawing and some of them have developed excellent technical skill at wielding the pencil or brush. Yet they are all troubled by the difficulty they encounter when they sit down before a blank sheet of paper and try to make a picture that really satisfies their inherent sense of what is right. Perhaps they have been taught to reproduce correctly on paper what they see before them, as a camera does, without leaving anything out or changing the position or form of any of the objects their view includes. Somehow, this process does not give them what they are really seeking, but they do not know what to do about it. It is these people I would like to help. I would like to set them free from the limitations of reproductive art, to give them command over the arrangement of pattern of line and light and shadow so that they will know what to do with the subject matter nature provides in such abundance if they want to make pictures that have the quality of good design. In my first book, "Pencil Broadsides," I devoted my efforts to an exposition of a particular technique of drawing with the graphite pencil, whereby a complete range of textures and values is attainable through the use of broad strokes, made with a flat, wedge-shaped point. I demonstrated this technique with a series of lesson sheets and a number of finished sketches in which the textures of the common materials of building and the rendition of a number of different types of trees were illustrated.

In presenting this second book, I am assuming that the reader has already attained some proficiency in the use and control of the pencil so that he may now concentrate his attention on a more important part of an artist's stock in trade; namely, the ability to combine and put together the elements of subject matter in such a way as to make pleasing pictures of whatever he chooses to draw.

The thing I would like to teach here is how to select and arrange the things found in nature so that the resulting pictures will have those qualities that will make them appeal to all normal tastes. There are certain principles of proportion, balance, rhythm, contrast, etc., that are followed either consciously or instinctively by all artists. These principles can be learned and applied by anyone who is in earnest about wanting to make pictures. Upon how intelligently they are applied depends the excellence of the results.

Naturally, with the pencil we are limited to black and white, a limitation which many people profess to believe makes this medium somehow inferior to water colors and oils in the making of worthy works of art. It is my belief, however, that the pencil, in the hands of a true artist, is capable of producing really fine results that can hold their own against pictures made by any other means. Certainly, the average person can learn to do as well with the pencil as he can do with the brush, and it is to the average person that this book is addressed.

The illustrations of this book are of two kinds. There are a number of what may be called Lesson Plates and numerous carefully studied Picture Plates in which have been applied the principles that will be described hereafter. Each Lesson Plate analyzes a picture and shows how it has been put together, both as to the arrangement of the pattern in line and the balancing of the principal light and dark values.

Each Lesson Plate also gives several additional small picture arrangements made with the same or similar elements. In the whole collection there is a great variety of subject matter, ranging from the seaside and waterfront to the hill and mountain country of the interior; with rivers, roads, rocks, and trees; with houses, boats, barns, and wharves as the elements out of which landscapes are built up. In making the illustrations it was my aim to show how there is picture material everywhere and how the artist can, by selecting the essentials and rearranging them to suit his purpose, grasp and convey the real truth and beauty in the scene that lies before him so that others may enjoy it. So, with this objective, let us go to work together, seriously, to make pictures.

FUNDAMENTAL STROKES

This lesson turns to the problem of indicating brickwork at both small and large scale. The illustrations show two examples which in scale are approximately what you might encounter in an architectural perspective rendering, but the principles back of their execution extend to cover any reasonable scale.

The same suggestion I previously made with regard to stone textures applies to brickwork. That is, you can to advantage go out before you begin to draw and look closely at a number of brick walls, making a mental note of the things that give them their character both when seen at a little distance and near at hand. Differences in color of individual bricks, shadows in the mortar joints, the type of bond, and the thickness of joints become of more importance as the scale increases. At the smaller scale, these things cannot be shown in detail but it is important to know that they exist if you want to be intelligent about suggesting them with your pencil.

At the smaller scale, one of the important things to look out for is the perspective direction of the brick courses. The example shown is seen almost in direct elevation and there was not much chance of going astray. When the surface of the wall is viewed at more of an angle, however, watch carefully to keep the direction of courses correct as you work down the wall.

Assuming that you have now laid out your drawing lightly, we will start to render it. Decide in your mind, if possible, how you are going to dispose your values to get an interesting composition with dark against light and light against dark and a sparkling play of sunshine and shadow. Begin to put in the darkest values. For the shadows, use broad diagonal strokes, making them not too dense and allowing occasional spots of white to break up any monotonous areas.

Now begin at the top of the brick surface to render the brick itself. In doing this, avoid monotony by varying the length of strokes from course to course. Do not indicate each separate brick but occasionally use a short stroke among the longer ones. Break the horizontal strokes by introducing diagonal lines once in a while and sometimes cover an irregular area with a series of short diagonals, keeping the value the same as adjacent brick courses. The wall in general should grade from dark at the top to light at the bottom. As you work down, you can leave more whites to show through between courses, but everywhere avoid monotony or regularity. To suggest weathering, use some vertical shading, particularly near the top where it would occur in nature. These vertical strokes can be put in either as you render or later, on top of earlier strokes. You can also put in some dark bricks here and there, but don't overdo it.

When you finish, if you are successful, you will have indicated a brick surface that has a convincing texture, that is full of interest, that provides contrasts where you want them, and that suggests shadows falling from nearby trees.

Turning to larger scale, the things you have now learned can be applied with more exactitude, but no less freedom. In the piece of wall shown at the bottom of the accompanying plate, the individual bricks show up more clearly but the surface is well broken up with diagonal strokes and areas shaded to the appropriate values. Here, the individual bricks appear as single strokes made with a properly sharpened pencil. They vary in value as the bricks themselves vary in color. Shadows have been indicated sharply under some of them and the mortar joints are left white in many places, taking care however to distribute the sparkling whites irregularly. If you practice copying this drawing and then apply what you learn to examples of your own invention you will acquire freedom and command as you go along.

If you do not succeed in producing a satisfactory result, it may be that you need to refer back to Lesson 1 and do some more practice of individual strokes. It may be because you are not keeping your pencil properly sharpened. Or it may be that you are not keeping in mind at all times that monotony must be avoided through variety of strokes, contrasting values, and opposition of forms. Only by exercising constant control over your whole composition, seeing it broadly while you are drawing in detail, can you produce a completely artistic result. But keep on trying.

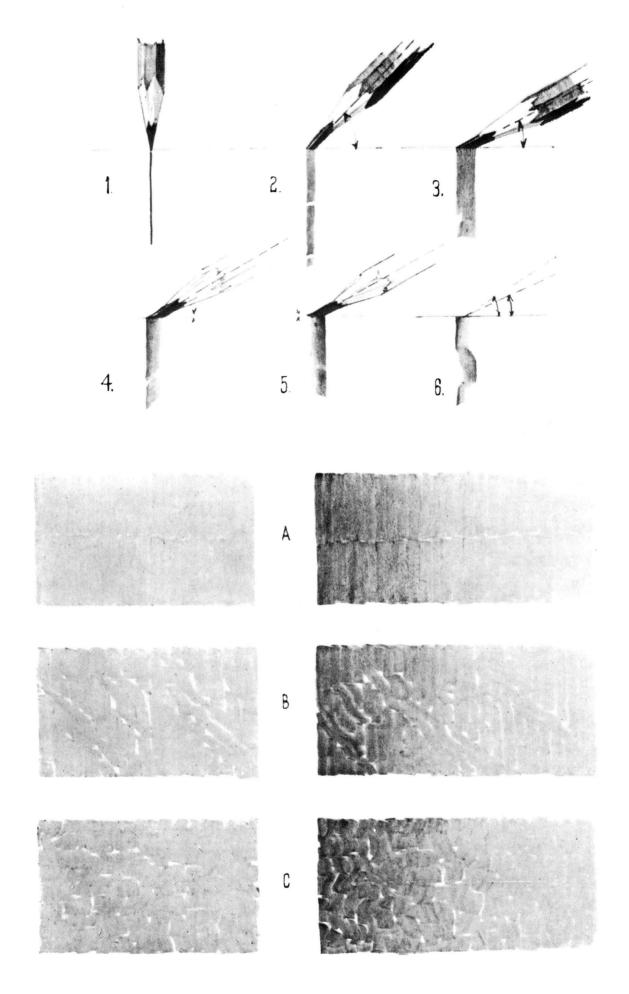

INDICATING STONEWORK

Having practiced diligently (I hope) the fundamental strokes described in the first lesson, and possessing as a result a reasonable degree of control over the pencil, you are ready to start on the indication of various textures. This lesson has to do with stonework.

While it is possible for you to begin right here, using as reference the examples shown opposite, it would be a wise thing to wait, before you draw, long enough to go outdoors and look at some actual stone walls. There are many things about them that you can observe with profit. Notice the variations in size and color and value of the individual stones in a section of rubble or random ashlar. See how a good mason composes them to achieve variety and texture and how he avoids monotony. See how the light falls differently upon each one and how the shadows and highlights arrange themselves in accordance with the roughness or smoothness of the work. Take note of the effect of reflected light from nearby surfaces or from the ground. The more closely you observe these things, the better able will you be to draw a convincing picture. Even if you are already familiar with stonework, you can always benefit by looking again.

Now come back to your drawing board and see that your sandpaper block is at hand and your pencil is sharpened properly. You are going to try to do what the good mason does — only you will do it on paper.

First you will have to sketch very lightly the pattern of the wall. As you do this, keep in mind the desirability of laying the stones horizontal, mixing the sizes to make a pleasant variety, breaking the joints to get a good bond. Bigger stones are good at corners to give them strength; smaller stones fill in among the irregular spaces between the big ones. If you are drawing a rough wall, avoid the monotony of pattern that would be caused by repeating stones of the same size or shape at regular intervals.

Decide where you want to focus the attention by giving your wall the greatest contrast with its surroundings. Begin there to put in the darkest values, shading individual stones cleanly with parallel strokes of the required weight. Do some

stones with vertical strokes; a few with horizontal for variety's sake. Or vice-versa. Occasionally, as you proceed from dark toward light, break the pattern with some diagonal strokes as you did in the last lesson at "B." Keep the edges of stones clean-cut by accenting the beginning and end of strokes slightly as already described. This applies particularly to the edges that silhouette against the sky or lighter areas.

Put in a few shadows along the bottom edges of occasional stones, watching the whole effect all the while to avoid spottiness. Leave clean white areas between stones to count partly as mortar joints, partly as highlights along top edges, but avoid monotony in this also by letting some strokes pass through from stone to stone.

By working from dark toward light, you can keep the entire area under better control and you will learn with experience that there comes a point where it is well to stop with some of the stones left white. The white areas give sparkle to the final result and are in accord with nature, where sunlight is almost totally reflected from surfaces upon which it falls at just the proper angle. Even in shadows it is well to leave a little white paper to show through here and there to express reflected light and break up otherwise uninteresting areas.

The same general method is applicable to any type of stonework. As the wall becomes smoother, individual stones are drawn with less gradation and the shadows under them become less pronounced. The same is true of the highlights. There is still, however, gradation from dark to light in the whole picture and individual stones are not all in the same value. The diagonal strokes are still used to give variety and to suggest the direction of falling light. Stiffness can be avoided without interfering with the general effect of accurate jointing and dressing, as may be seen in the example at the bottom of the accompanying sheet.

Three types of stonework only are shown. In them, nevertheless, you can find the principles by which to indicate any of the many varieties of texture you will see in buildings, stone fences, etc., as you travel about. Try many of them.

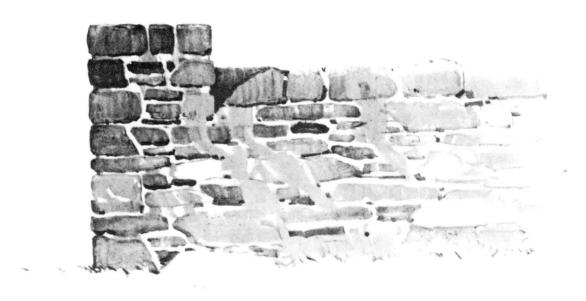

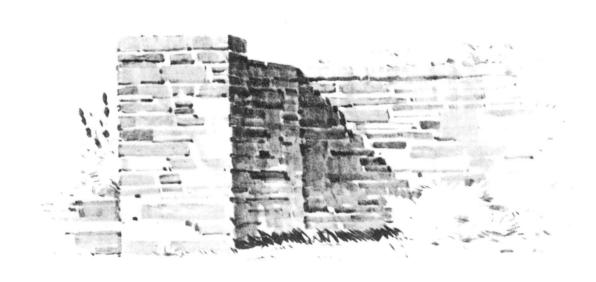

INDICATING BRICKWORK

The sketches shown in Lesson 4 illustrate the handling of a sufficient variety of wood textural problems to keep you busy practicing for a while. The first example, at the top, includes weathered shingle roof and shingled walls painted, let us assume, white.

Begin, as usual, after laying out the sketch lightly, by putting in the darkest areas. The principal one of these, in the subject chosen, is the roof. In indicating this there are three things to be shown — the tone of the roof itself, weathered or perhaps stained to a rather dark value; the contrasting tone of the end grain showing along the butts, which resolves itself into a series of parallel but slightly irregular and discontinuous lines; and the still darker shadows falling across the roof, cast by the chimney and nearby trees. This analysis suggests three principal directions for your strokes broad strokes paralleling the grain of the shingles to cover the general tone, narrower strokes along the lines of butts, and broad strokes following the direction of falling light. Start by laying in the general value of the roof area with long and short broad strokes. The shortest ones will be determined by the height of a single course or row of shingles.

Since the tree and chimney shadows will be the darkest values, it will be economical of effort to put them in early in the game, using strokes whose direction follows the direction of light.

Now, using your pencil with a narrower surface in contact with the paper, put in some of the irregular parallel lines which represent the butts of the shingles. As you will observe by looking at a shingle roof, these strokes should not be straight and stiff and they should vary in thickness slightly from point to point. They should not extend over the entire surface of the roof, but only enough to give a realistic effect.

Indication of the dark accenting shadows of the doorway and the window lights can be done at this point or even before, the idea being to keep everything in proper relation to the whole as you proceed. The door itself, as an important part of the center of interest, should be given its proper value with carefully controlled broad

strokes, leaving highlights along the edges of the rails and stiles. The dark foliage and the tree trunks can be indicated at this stage also. Do this rather carefully and deliberately, taking care to silhouette the corner of the house with a slightly saw-tooth effect to express the overlapping rows of shingles.

The same procedure as for the roof may be followed for the walls except that here the shadows, which supply the principal means of distributing interest, should definitely come first. Draw them in with broad gray strokes, with some feeling for reality and also with some understanding of how they will modify contrasts. The strongest contrasts should come near the center of interest. Therefore, where you have a dark value which, if silhouetted against a light area, would draw the eye powerfully to that point, you reduce the contrast as needed to keep the interest where it belongs. The right-hand end of the roof, if set against the white sky, would be too prominent. For this reason, I have put in some gray foliage and tree trunks to soften the contrast. (This foliage, incidentally, extended upward, is useful in defining the corner of the chimney.) You can find other places illustrating the principle.

Having cast the necessary shadows which help to keep your composition in hand, you can now indicate the shingle courses by rows of short, broad, vertical strokes for the shingles themselves and narrow horizontal strokes for the shadows at the butts.

Passing now to the sketch in which rough siding is represented, there is little to be said that will not be evident upon thoughtful inspection of the drawing. The principal area is all put in with broad, vertical strokes and the edges of the siding with their shadows are more irregular in spacing and direction than those of shingles.

Having gone so far, the indication of the clapboarded house should present no difficult problem. Work from dark to light, as always, and put your foliage shadows in before accenting the shadows under each row of clapboards. Restrain yourself as you work along, always trying to determine, in time, the point at which to stop.

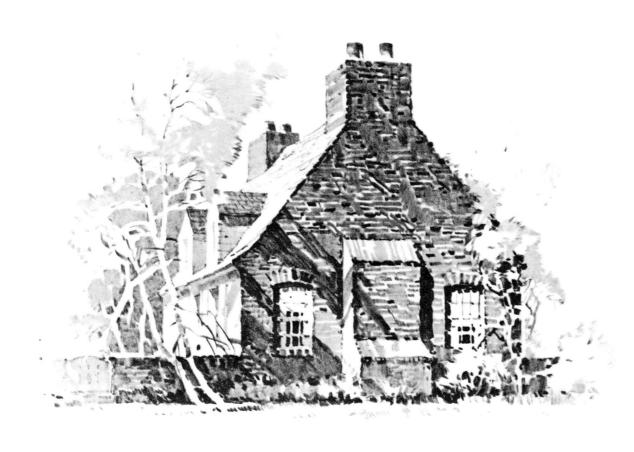

A FEW WOOD TEXTURES

The sketches shown in Lesson 4 illustrate the handling of a sufficient variety of wood textural problems to keep you busy practicing for a while. The first example, at the top, includes weathered shingle roof and shingled walls painted, let us assume, white.

Begin, as usual, after laying out the sketch lightly, by putting in the darkest areas. The principal one of these, in the subject chosen, is the roof. In indicating this there are three things to be shown — the tone of the roof itself. weathered or perhaps stained to a rather dark value; the contrasting tone of the end grain showing along the butts, which resolves itself into a series of parallel but slightly irregular and discontinuous lines; and the still darker shadows falling across the roof, cast by the chimney and nearby trees. This analysis suggests three principal directions for your strokes broad strokes paralleling the grain of the shingles to cover the general tone, narrower strokes along the lines of butts, and broad strokes following the direction of falling light. Start by laying in the general value of the roof area with long and short broad strokes. The shortest ones will be determined by the height of a single course or row of shingles.

Since the tree and chimney shadows will be the darkest values, it will be economical of effort to put them in early in the game, using strokes whose direction follows the direction of light.

Now, using your pencil with a narrower surface in contact with the paper, put in some of the irregular parallel lines which represent the butts of the shingles. As you will observe by looking at a shingle roof, these strokes should not be straight and stiff and they should vary in thickness slightly from point to point. They should not extend over the entire surface of the roof, but only enough to give a realistic effect.

Indication of the dark accenting shadows of the doorway and the window lights can be done at this point or even before, the idea being to keep everything in proper relation to the whole as you proceed. The door itself, as an important part of the center of interest, should be given its proper value with carefully controlled broad

strokes, leaving highlights along the edges of the rails and stiles. The dark foliage and the tree trunks can be indicated at this stage also. Do this rather carefully and deliberately, taking care to silhouette the corner of the house with a slightly saw-tooth effect to express the overlapping rows of shingles.

The same procedure as for the roof may be followed for the walls except that here the shadows, which supply the principal means of distributing interest, should definitely come first. Draw them in with broad gray strokes, with some feeling for reality and also with some understanding of how they will modify contrasts. The strongest contrasts should come near the center of interest. Therefore, where you have a dark value which, if silhouetted against a light area, would draw the eye powerfully to that point, you reduce the contrast as needed to keep the interest where it belongs. The right-hand end of the roof, if set against the white sky, would be too prominent. For this reason, I have put in some gray foliage and tree trunks to soften the contrast. (This foliage, incidentally, extended upward, is useful in defining the corner of the chimney.) You can find other places illustrating the principle.

Having cast the necessary shadows which help to keep your composition in hand, you can now indicate the shingle courses by rows of short, broad, vertical strokes for the shingles themselves and narrow horizontal strokes for the shadows at the butts.

Passing now to the sketch in which rough siding is represented, there is little to be said that will not be evident upon thoughtful inspection of the drawing. The principal area is all put in with broad, vertical strokes and the edges of the siding with their shadows are more irregular in spacing and direction than those of shingles.

Having gone so far, the indication of the clapboarded house should present no difficult problem. Work from dark to light, as always, and put your foliage shadows in before accenting the shadows under each row of clapboards. Restrain yourself as you work along, always trying to determine, in time, the point at which to stop.

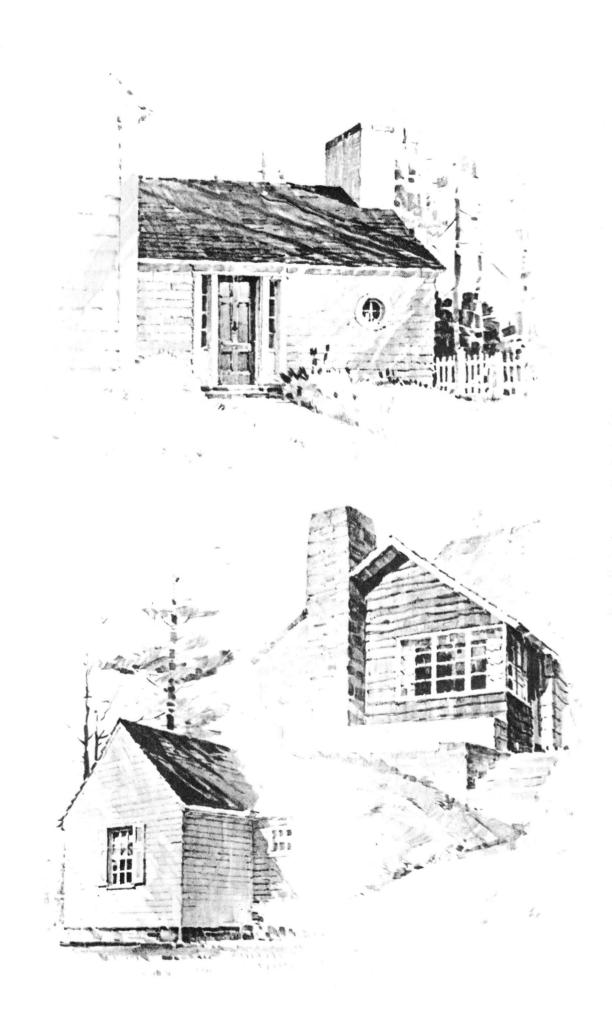

DRAWING THE PINE TREE

For the next few lessons I am going to discuss the drawing of different types of trees. Many people who can make a satisfactory representation of an architectural subject seem satisfied if they can suggest its setting by means of nondescript or stereotyped trees and shrubbery. I feel very strongly that it is worth while to learn to draw trees that really look like trees and that can be identified as oak or birch or pine or some other definite species.

The first essential is an understanding of the tree structure. You should, by observation of actual specimens, fix in your mind the characteristics of each kind of tree, the relation between its various parts, between trunk and branch, twig and leaf, and so on. Realize that it is a three-dimensional object which can be thought of in terms of plan as well as elevation. Light falling upon it will strike full against some of the foliage masses while others will be in shade or in shadow. Some of the branches extend towards the observer, some away, and some to either side of the trunk. These things seem elementary, but I have seen so many drawings which show a disregard for the simplest facts of tree structure that it is worth while to point them out. By keeping them in mind you will avoid drawing the hard, formless silhouettes or feather-dustery monstrosities that so unnecessarily mar the work of many amateur sketchers.

At 1, 2, and 3 on the accompanying plate, I have diagrammatically shown a section of weatherbeaten pine tree with four branches. In plan, the branches, each bearing an irregular mass of needles, radiate in four directions from the trunk, filling out a rough circle. In elevation, the four branches appear at different levels, extending out and down from the trunk and terminating in up-curving, finger-like twigs supporting the foliage. With light falling from the left and above and striking the tops of these foliage masses, the sides you are looking at would be about as shown, generally dark in value with a suggestion of sunlight along the top surfaces. Where the foliage is in back of the trunk, the trunk will appear light against the dark needles beyond. Where the branch comes

out towards the light, its foliage casts a shadow on the trunk below. So much for this analysis, the application of which will become clear as you proceed with a finished sketch, either a copy of this plate or composed according to fancy.

In young pines the branches start from the trunk at an upward angle. As the tree grows older and the foliage masses become heavier and extend farther out from the trunk, the branches are weighted down into a graceful, elongated S-curve. At first there are possibly six or more radiating branches at each level. In the tree's life, however, branches break off or are cut off until when it becomes old it is likely to be irregular and picturesque like the ones shown here. One can take liberties in arranging the foliage of this sort of trees to conform with the requirements of a picture, without much danger of departing from reality, provided the general rules of structure are not violated.

In rendering the foliage of these trees, I have used short broad strokes for the most part, with narrower radiating strokes, made with the narrower side of the broad-pointed pencil, around the edges of each mass. This treatment makes a clean, sharp silhouette against the sky, which is left white, and suggests, without being too literal, the needles which make up the foliage.

While the general tone of evergreen foliage is dark, you will note that I have made the portions receiving the light from the sky distinctly lighter than those portions in shade, away from the light, or in shadow. You will also observe, in some places, allowance for light reflected up from the ground into the shaded areas.

The branches and twigs either silhouette dark against the sky or light against dark foliage behind them. Since the bark is comparatively smooth, it may be rendered with broad strokes laid with a little texture. Where, for purposes of composition, a light area of foliage needs to be suggested, as in the branches vignetting at the upper right of our little picture, it is convincing enough to put in the radiating zig-zag strokes around the edges. The eye is satisfied because the more completely rendered masses of the other trees have told the story by suggestion.

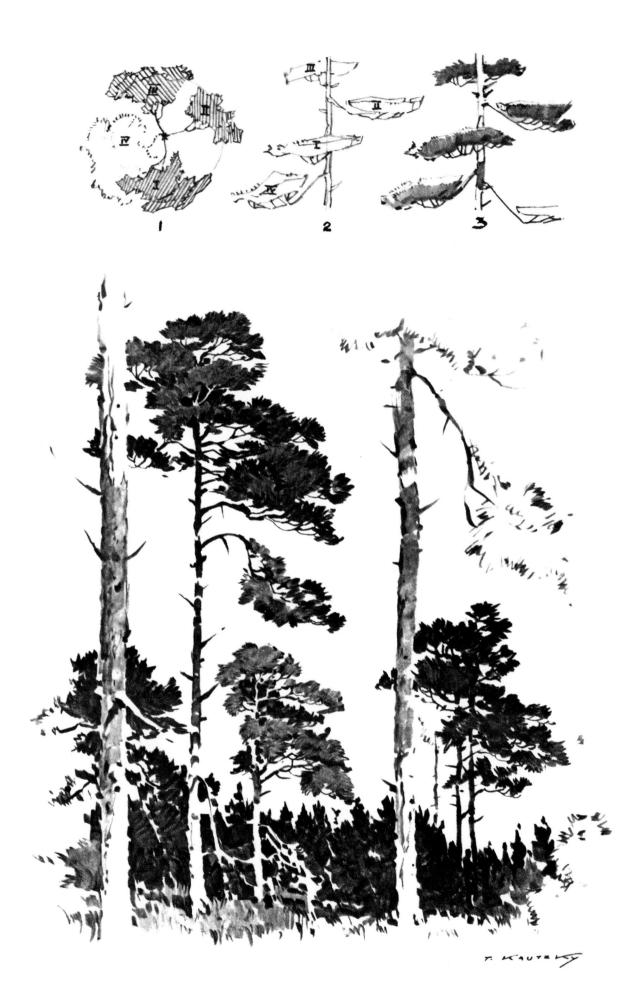

DRAWING THE OAK TREE

In discussing the correct drawing of trees, I wish to make it clear that my interest in distinguishing between species is not that of a scientific botanist, nor do I pretend to any botanical exactitude in my drawings. I regard the trees I draw from the point of view of an artist who wishes to be convincingly truthful and who loves trees for the sake of their interesting forms, the rhythmic lines of their structural elements, and the play of light and shade and color through their foliage masses.

The oak, which is the subject of this lesson, offers marked contrast to the pine, which was treated in the last plate. Characterized by great strength of structure, its heavy trunk and gnarled twisting limbs support a broad, heavilyleafed crown. I have chosen to illustrate here a rather symmetrical example—one whose spreading branches extend about as far horizontally as the tree reaches vertically. The general shape of the whole might be roughly contained within a great sphere and if you keep this thought in mind you will feel the form as you render it. As usual we begin by drawing lightly the structure of the tree, its thick sturdy trunk tapering up from the ground, dividing itself into several principal limbs which throw off heavy branches as they ascend with many undulations towards the top, reducing gradually their diameters until they divide into smaller branches and twigs which carry the leaves. From the main limbs extend occasional turnings, twisting minor limbs, struggling their way towards the enclosing periphery, crossing and recrossing each other as they go and casting their shadows on their neighbors. We also sketch in the foliage masses and suggest lightly the shades and shadows preparatory to their final expression with broad strokes. The light in this case is falling from the left, above and behind the observer. Keeping in mind the ball-like general mass, you will be able to determine where the lighter and darker portions will occur and cast the foliage shadows on branch, trunk, and ground. When you have drawn your tree something like the little diagram at the top of the plate, only much lighter, you will be ready to go ahead, with essentials established.

Start with the darkest areas, putting them in with broad strokes, rather short to suggest leafage and remembering to silhouette the edges of each mass sharply against the sky with appropriately irregular profile. Heavy limbs in shadow may be shown by strokes running either lengthwise or crosswise. The short strokes running crosswise give a slight vibration to the profiles of the limbs, which is in accord with the roughness of the bark and at the same time helps to suggest the play of reflected light. Longitudinal strokes may be used for the smaller branches and for limbs which catch the light on one side. Remember that limbs and branches passing in front of dark areas should be left white where they catch the light or gray where you want them to show up in shadow. Against the light sky they should show up as clean dark strokes, their values varying with light conditions. It is these many contrasts which give the sparkle to your drawing and fill it with life. As you render the foliage masses, have in mind

As you render the foliage masses, have in mind the way the leaves radiate from the twigs and branches. While you do not draw in each leaf, your individual strokes will suggest their directions, particularly around the edges. Try as you draw to feel the form of each mass and to model it with variations of tone while keeping its general value in proper key with the whole.

Observe how, on the darker side of the trunk and principal limbs and even in the darkest foliage masses, I have taken into account the reflected light from the ground which helps to express form and adds interest. Your skill in maintaining variety of surface in every part of your sketch while keeping it all in proper relation to the whole will develop with practice, just as mine did. Do not be content with just one or a few trials. Make many. Go outdoors and draw from nature. Compose some trees of your own. Do not forget throughout all this that the proper and frequent sharpening of the pencil is a fundamental preliminary to this particular technique. Success depends upon the clean-cut and precise application of pencil to paper with each stroke calculated to be of maximum expressiveness. An uncontrollable point won't work.

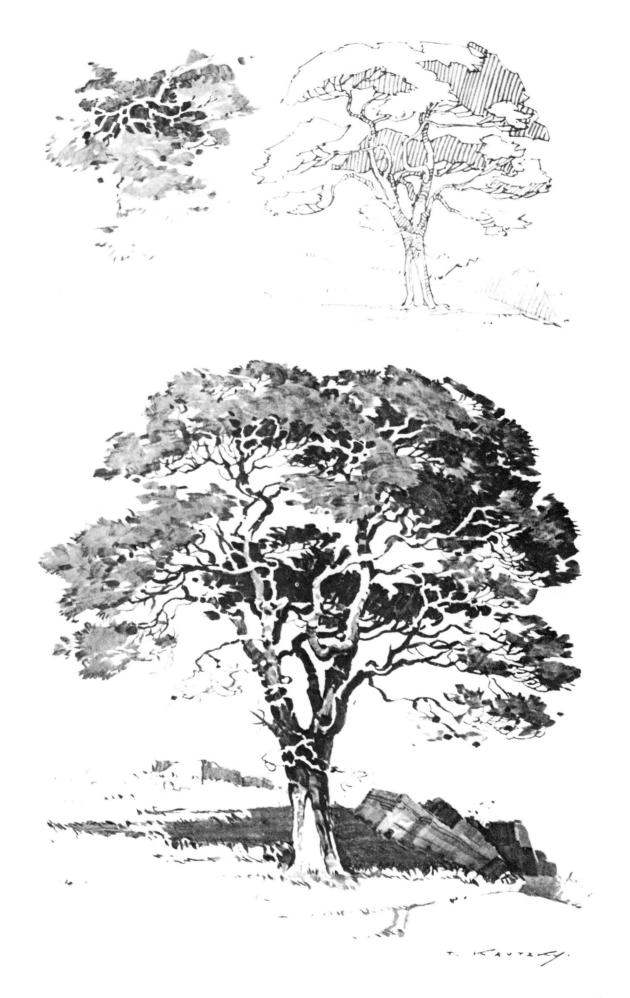

DRAWING THE BIRCH TREE

Just as the oak is strong, rugged, and masculine, the birch, which we will now study, is delicate, graceful, and feminine in its characteristics. I am, of course, thinking of the ordinary white birch seen so frequently in suburban landscapes rather than of the great canoe birch which is found in the virgin forest rising to considerable heights and sometimes having impressive girth. The type of birch I mean grows commonly in clusters - several stems from a single root system. So I have chosen to illustrate a cluster of three in which the trunks, as often occurs, have departed from the straight line of uneventful growth and have acquired that character which comes from a certain amount of struggle for survival in the face of difficulties. Because they have this character they become more interesting to draw and compose more effectively.

We begin, as usual, by blocking out the general forms and masses to establish the proportions of the principal foliage groups and their relation to the slender stems. Two stages of this blocking out process are suggested lightly at the top of the accompanying plate. In the first step, the trees alone are roughly arranged in a group. Carried a little further, the composition is seen to need the addition of a mass of shrubbery behind it to avoid top-heaviness and the foliage of the trees needs to be elaborated a bit and treated in a manner more suggestive of leafiness.

When we have gone this far and have our intentions well in mind we can begin boldly to lay in the values we have decided upon for our composition. The central tree of the group, which is in back of the other two, we determine to make the darkest so as to hold the picture in balance. This decision also enables us to silhouette the trees in front as light against dark, increasing the three dimensional feeling.

Note that the foliage of the birch is thin and tremulous, with lots of openings through which the sky shines and lots of leaves, stirred by the wind, turning their silvery under surfaces to the observer. Many single leaves stand out from the rest, especially around the edges of foliage masses, contributing to the sparkling effect. It should be your aim to express these peculiarities

in your sketch. You can do it by using rather short broad strokes, changing their directions all the time and varying their shapes to simulate leaf forms, not too literally but suggestively. Also leave frequent whites.

As with the other trees, the principle of setting light against dark and dark against light is employed to define shapes of stem and branch and leaf mass. This principle holds good even though the bark of the birch trunks and limbs is predominantly white. They will still seem dark against the sky in many places. Where the trunks are silhouetted white against the dark foliage of the shrubbery there will be enough lightness to carry the impression of the light bark throughout the sketch.

In putting tones on the trunks and larger branches it will be well to use short strokes running crosswise rather than longer strokes running lengthwise. Somehow this treatment expresses better the quality of the bark, which has a horizontal grain as is known to every one who has peeled a birch tree. Occasional breaks in the continuity of the shading, leaving white gaps not too long for the eye to carry past, are also in character with this tree. The little section in the upper right-hand corner of the plate will show what I mean.

Be sure to keep the trunks properly slender and tapering delicately all the way to the top. The branches usually tend to curve up from the main stem, particularly near the top of the tree where they are shorter. Lower down they may tend to be more horizontal or to bend down if they have had to carry heavy foliage during the tree's life. Ice storms often permanently change their curvature.

I cannot emphasize too much the importance of the silhouette of foliage masses in conveying the character of a tree. Whether you are conscious of it or not as you look at a specimen you are getting an important part of your impression from the way the edges are broken up against the sky or against other trees or buildings. Try therefore to discern as well as you can what the identifying marks are and give particular care to putting them down in your sketch.

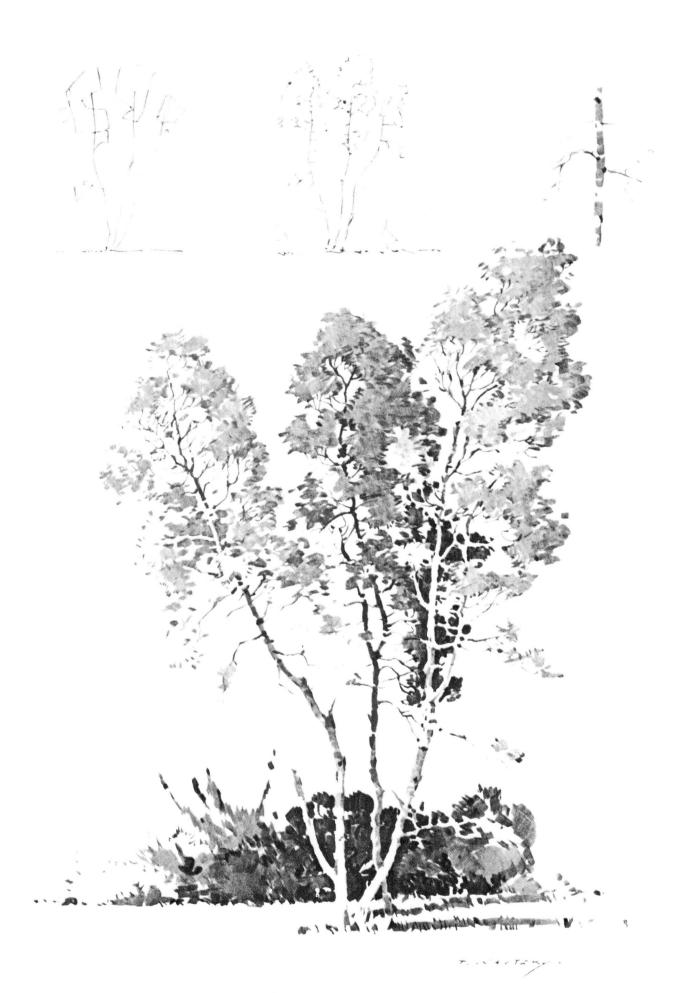

DRAWING THE ELM TREE

One of the loveliest of our American trees is the elm. Despite the ravages of diseases and parasites and destructive storms, this graceful tree is still found in great numbers distributed through the greater part of this country.

In general form, the skeleton of the elm might be approximately contained within a narrow inverted cone, at least until it nears the top of the tree. Here, its limbs curve out gracefully and continue into the smaller branches which bend down under the weight of the leafage.

The trunk of the elm is substantial. Its lower portion thickens at the base and merges into roots extending downward like great fingers designed to achieve a firm grasp of the soil. Its upper part divides as it begins to spread outward, at a height of perhaps ten to twenty feet above the ground, into continuously tapering limbs. A section through the trunk of the mature tree is commonly not circular but shows bulges which indicate the beginnings of the limbs. These bulges become more pronounced as the point of division is approached, so that they develop naturally into the separate limbs above.

The crown of the tree tends to take the form of an arch, or rather a dome, which is filled out more or less according as the tree has a full, healthy growth or is thinly developed for lack of nourishment or otherwise.

The little sketch in the upper left of the accompanying plate indicates the general envelope of the tree I have taken as my example. This has been more fully developed into the skeleton and foliage masses as seen at the upper right. As with the other trees we have studied, we begin our sketch thus by establishing its essentials.

In the sketch fully developed on the plate, it will be noted that I have used both types of stroke in modeling the trunk, limbs, and branches. Some of the strokes are curved to suggest the form of the limbs and define the shadows falling across them. As in the preceding lessons, where the limbs or branches occur against a background of foliage, they are left white. Where they are seen against the sky they are dark in shadow, gray in light.

In expressing the foliage, short, broad strokes,

slightly curving and following the general direction of the arching sweep of the tree's crown, are applied with values already decided upon in accordance with the way the light falls. The portions of the foliage receiving most intense light may be completely highlighted, suggested only by a few strokes around their edges or by silhouetting them against darker masses. Portions receiving normal light will be shown by various degrees of gray. Keep plenty of variety in these gray areas and allow bits of white to show through here and there. Watch the silhouettes of the edges of each group of leaves so that they will be suggestive of the way the leaves hang down. It may be well at this point to turn back and compare this tree with the oak shown in Lesson 6. You can see by comparing the two plates, better than I can tell you in words, the difference in character of the strokes used. While the individual strokes do not stand out too prominently, they count enough to give direction to the leaf arrangement and differentiate one type of tree from the other so far as that feature is concerned.

One of the things you must always have in mind, just as in drawing other subjects, is the matter of proper proportioning. The weight of the trunk and limbs of each kind of tree bears a characteristic relationship to the whole tree. I mention this because I often encounter drawings of elm trees where the trunks are too thin in proportion to the rest. Note the apparent swelling in the size of the trunk where it merges into the limbs and also the merging of the trunk into the principal roots at the point of contact with the ground. When you once see these things you will never thereafter be guilty of drawing elms that seem to have smooth cylindrical trunks, resting on the ground like up-ended pipes and branching abruptly into smaller pipes.

Now please do not immediately undertake to prove me wrong by bringing up examples of elm trees which do not conform to the general statements I have made. There are exceptions in nature to almost every rule, but what we are trying to do here is to learn how to draw trees which satisfy the artistic eye yet are natural.

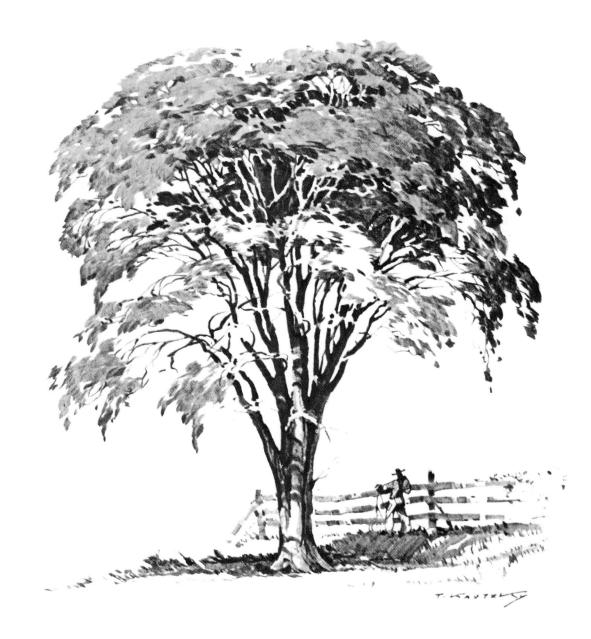

MORE ON ROOF TEXTURES

Having learned something about drawing trees, upon which we have been concentrating for the last four lessons, let us turn again to the problem of indicating the textures of architectural materials. For this lesson I have chosen as examples two different types of roof—one of tile, old and weatherbeaten, and the other of slate, new but pleasantly irregular of surface.

Recall that in Lesson 4 we decided that the shingled roof required three principal directions of pencil strokes — parallel to the grain of the wood, parallel to the shingle courses, and parallel to the direction of light. The same general rule may be applied here. The difference between the rough and the smooth texture is achieved by the greater or less degree of irregularity of the individual strokes, not by their general directions. The irregularity of the strokes is to be found in their departure from both straightness and uniformity of tone.

The quality of any texture can be best rendered by one who comprehends how that texture came into being. This means knowing not only how the individual units are put together and supported to form, for example, a roof, but also the characteristics of these units—shingles, shakes, tiles, slates or whatnot—and, most important, the things that happen to such surfaces by the action of nature over a period of time.

Rain, falling upon a sloping roof and running down its length, streaks it with dirt washed from the sky or previously deposited by the wind. Melting snow does likewise. Alternate wetting and drying, heat and cold, affect soft materials like wood while leaving harder substances like slate or terra cotta essentially unchanged in form. Shingles and shakes become furrowed as the softer part of their grain is eroded away and also tend to curl up at the edges instead of lying permanently flat. Sagging between rafters tends to develop with age in wood construction, producing a more or less perceptible waviness across a roof that has yielded again and again to snow loads and wind pressure. Wind-blown seeds and spores find lodging in the crevices of a roughly textured roof and some of them develop into mosses and lichens if conditions are

favorable. Shingles or slates become loosened in old roofs and slip out of place or even blow completely away. All of these things and many more enter into the development of a roof texture. Understanding them, you will be better able to draw convincingly. Imagination, the ability to see beyond the obvious, to penetrate with your mind below the surface of things, is necessary if you are to be an artist. But we degress, perhaps!

The examples shown here illustrate many of the things I have dwelt on during all the preceding lessons. Must I really point them out to you? The cleanly-defined broad strokes with few dominant directions; the gradation of tones; the contrasts of light against dark, dark against light; the avoidance of monotony; the sparkling little flecks of white paper showing through; the carefully considered silhouette: you can surely see them. And what I can do, you can do—if you will only work, and THINK!

It is all right, if you wish, to copy these sketches, just to get the feeling of the different type of strokes and to develop capacity to produce deep darks and delicate lights simply by varying the pressure of pencil on paper as described in Lesson 1. More important to you, however, is the making of many sketches of your own, working direct from nature if possible. You will find many textures not illustrated here and it is your job to express them as well as you can. The same fundamental strokes can be used for all of them, the general principle of this particular technique being to use broad strokes, for the sake of economy of effort, wherever possible. Narrow strokes may be used, where your intelligence directs, for definition or accents. You will find plenty of places in the sketches in this series where I have used narrow strokes but I do not believe you will find any where broad strokes would have done the work. I mention this simply because I have frequently encountered the type of student mind that delights in pointing out instances where the teacher has apparently disregarded his own instructions. Rules, of course, are made to be broken but it requires experience to know exactly when to break them.

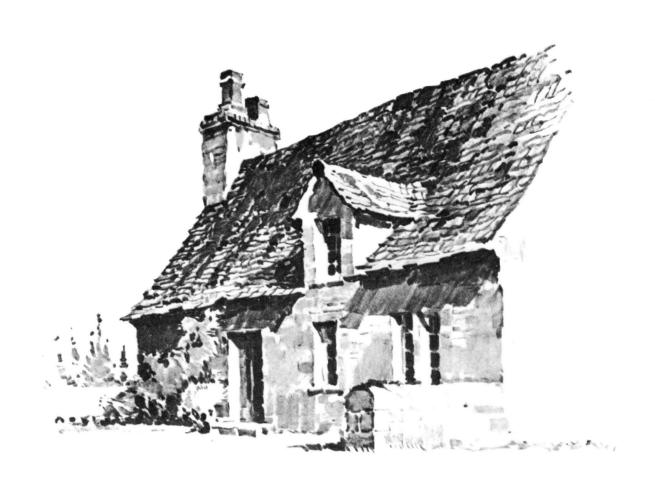

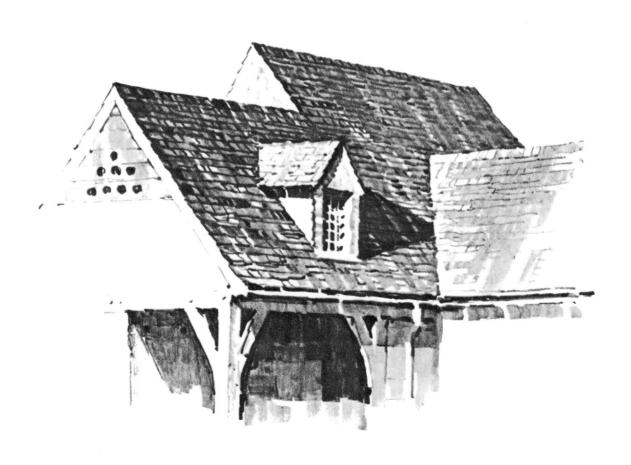

EVERGREEN SHRUBBERY

Dark accents in the landscape settings for architecture are frequently furnished by shrubs and hedges of yew, box, and other hardy evergreens. Sometimes these are clipped and sometimes they are left to take their natural forms but in any case they constitute a special problem for the artist or delineator. Their close, compact growth and their dark tones make them conspicuous elements in the picture in which they occur. They must therefore be drawn with care and sufficient naturalness.

The sketch at the top of the accompanying plate shows a suburban house of common enough type with a setting of rather formal planting. The most prominent features of this landscape are a thick box hedge in the foreground and some clipped evergreen tree forms which might well be English yew, or perhaps cedar. Nearer to the house is a hedge with an evergreen arch framing the garden gate. The dark values of these elements outweigh any other dark tone in the composition. To render them properly will call for heavy pressure with your 4B pencil properly sharpened to produce clean broad strokes.

As a preliminary to tackling the problem presented by this sketch or one of your own composition involving similar elements, I advise (as I have done before) that you go outdoors and look at some actual samples of box, yew, cedar, and other evergreens. Observe the bubbling forms of the box, its texture, the way the light falling upon it models its shape and reflects from the portions in full sunlight, making almost highlights. Notice in the cedars how there are occasional gaps in the otherwise close growth, through which you can see bits of branch, or even the sky. Mark particularly the silhouette, whether or not the specimen is clipped, standing with more or less irregularity against lighter areas beyond. See how the contrast of dark against light gives the illusion of an aura extending along the line of separation. Get all these impressions firmly in your mind and then come in and go to work.

In drawing the box hedge shown on the facing page, I have used several types of broad strokes, which have, however, but two general purposes.

One group of strokes serves to define and model the general forms while the other is directed to the expression of texture. The former are rather long, curving strokes, sometimes wavy, and they follow the contours of the bushes quite clearly. Their variations in tone are calculated to indicate the play of direct and reflected light across the interlacement of globular surfaces which characterize this plant. The other set of strokes are short and multi-directional. They may be seen most distinctly on the nearest bush at the left. The suggestion of leafage which these convey is strong enough to carry the impression through the whole length of the hedge, especially when reinforced by the wavy or zigzaggy strokes of the first category. I have let the white paper show through here and there to express the highlights that occur where the sun reflects from the shiny foliage at the proper angle. Note that, though the general tone of the whole is dark, there is plenty of variety, as there would be in nature. Even in the blackest shadows the density is not complete.

The tall, clipped trees are modeled as cylinders, with reflected light bringing out the roundness of the shadow side. Here, too, I have used a number of short strokes running in many different directions and also have taken particular pains to accent and properly portray the irregular silhouette. The same remarks apply to the hedge and gate beyond. Note throughout the sketch that I have left a thin though irregular strip of white paper along the top and lighted sides of these evergreen forms. This helps the general sunny effect and accords with truth.

The hedge at the bottom of the plate is intended to be privet, which may not be, strictly speaking, an evergreen. It is rendered with a great many short strokes, laid closely in all directions. I have been careful to define the silhouette in character with the plant and have left a number of irregular openings in the foliage through which some of the stems and twigs may be seen. This makes a more interesting and none the less truthful picture than if I had assumed a solid growth of leaves. Longer diagonal strokes, following the direction of light, were used for the shadows.

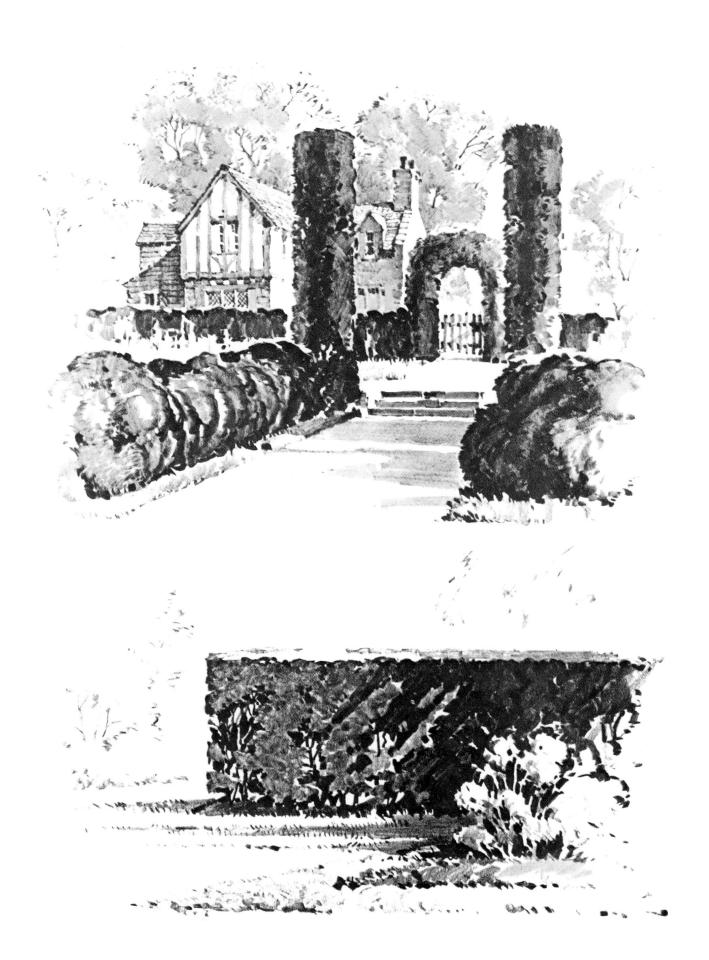

INDICATING FLOWERS

Occasionally, when sketching garden scenes or bits of architecture, it becomes necessary to include some flower groupings or borders. It is therefore a good idea to be prepared to handle this special problem. The problem becomes easy if you remember one simple principle—it is the silhouette that counts most. I am of course thinking in terms of sketches at relatively small scale and not of close-up, still life studies of flowers where more detail is called for. But even in the latter case the silhouette is always very important.

The two sketches on the accompanying plate illustrate the principle as applied to small and medium scale representation. The little garden pool and fountain above is set off to advantage against a bit of clipped hedge which also serves to make the flowers seen more effectively. This principle of placing flower beds where they will have a background of dark foliage is well known to garden designers and you can find innumerable instances of such treatment, both formal and informal. The advantage it gives to your sketch is obvious. By making the hedge suitably dark and letting the flowers stand out against it, a sparkling result is accomplished, almost colorful in its effect. It will be noted that it is entirely unnecessary to draw or indicate individual petals. The shape of the flower as seen silhouetted against the dark hedge is sufficient identification, taken together with its leaves and stems, to permit you to be just as literal as you wish. A little study of different species of flower plants will give you a working repertoire of forms that will equip you for sketching any garden you are likely to encounter in reality or in imagination. Where the dark background is not present, as for example to the right and left of the hedge in my sketch, the silhouetting is done in reverse - dark against light. Different degrees of gray will suggest different hues for the blossoms.

At the bottom of the plate I have drawn, at somewhat larger scale, some flowers planted against the base of a house. The house is light in color, but open windows provide some dark areas against which a few blossoms stand out clearly. The shadows cast by the plant foliage

also make dark areas along the bottom of the wall which cause the sunlit leaves to stand out sharply. Your problem is thus to define the various shapes plausibly, in accordance with your observation and knowledge, blending the contrast of dark against light and light against dark so that the observer will not be conscious of where one type of contrast leaves off and the other begins. As usual, the greatest degree of contrast will be at the center of interest with softer contrasts towards the edges.

You have by this time been drilled enough in the application of broad strokes, long and short, straight and curved, so that I do not feel that it is necessary to go through an analysis of this plate from that point of view. As always, it is necessary to keep your pencil well and frequently sharpened and to exercise all the control of which you are capable over each individual stroke. So far as you fall short of complete control your sketches will be fuzzy and will lack that crispness for which, I presume, you are striving.

This is as good a place as any to encourage the exercise of freedom in composition, tempered with understanding of what you are doing. If you are sketching from nature, you do not need to adhere literally to what you see before you. You may move trees or bushes or rocks about to fit the needs of your picture, provided of course you do not place them in some impossible position. You can exaggerate the slope of a hill or suppress it, all within the bounds of common sense. Such things as architecture you had perhaps best take as they are, unless you are an architectural designer who knows why and how things are put together. Even with buildings, however, you have some latitude - in the handling of shadows cast upon them, for example. In drawing trees, you can take liberties with the placing of branches, so long as you are true to species, or you may omit portions of the foliage if by so doing you make a more pleasing composition. In short, by using your brains you can be the master of your picture instead of letting it master you. Until you have acquired this mastery, you cannot fairly be described as an artist.

COMPOSITION POINTERS

We now come to what is perhaps the most difficult thing for the young artist to grasp — the baffling subject of Composition. It is not a matter of rules, though there are certain guiding principles that are generally taught and which are helpful. They are to be found in many books. In the end, however, the quality of the results obtained springs from some inborn artistic sense which you either have or do not have. The real artist must have it. With it, he frequently defies the rules or laws or whatever you may call them, and produces masterpieces of arrangement that could never have been arrived at by conformation to any established standards. Yet it is not for beginners to set out to break precedent and for that reason they had best acknowledge certain principles that experience has found generally reliable. A few of these are illustrated by the little pairs of sketches shown opposite. Since I omitted to number these on the drawing, let us agree to refer to them in discussion as 1, 2, 3, 4, and 5, reading from the top down. Faults occur in the left-hand column and are to be seen corrected, in a simplified way, in the right-hand column.

Sketch number 1, in its initial form, is too strongly dominated by horizontals and also lacks a definite center of interest. It needs some vertical accents to break up the monotonous horizontal movement and also will benefit by increasing the contrasts near the doorway and tapering off their strength to the right and left. By introducing a tree or two rising from behind the building we can achieve the required vertical contrast, carefully avoiding stiff symmetry by balancing foliage masses of different size around our chosen axis rather than centering one upon it. The horizontality is further reduced by changing the direction of the shadow strokes across the foreground. The rearrangement of contrast in value is obvious; its effect undeniably beneficial.

Number 2 shows a view down a road with all the perspective lines converging to a point far at the left. The result is unsatisfying because the eye is constanty being pulled out of the picture. We must insert some elements to stop this wan-

dering of attention and hold it near the center of the picture where it belongs. So we strike in a telegraph pole which furnishes a strong barrier across the eye-compelling convergencies, placing it where it will define the left-hand limit of the central area of interest. Because a vertical pole alone would be stiff and uninteresting, we tilt it a little, give it some supports, and let some poison ivy soften its otherwise hard profile. We also put in a background tree behind the row of houses. Its position keeps the pole from jutting too prominently into the sky and it also helps to direct the eye back to the center of interest which we now emphasize with increased detail and contrasting values. A suggestion of grass and weeds along the edge of the road, accented with a shadow from the pole, join with a few strokes laid across the road to keep the attention from wandering out at the lower right.

The third sketch suffers from too strong contrasts at the left side, the relatively unimportant tree getting all the attention. The house, after all, is the most interesting element here. By rearranging the values as shown, better balance around the center is achieved and the house now stands out clearly. The dark tree compensates for the dark gable end. The tree at the left is still there but is well grayed down and the dark shrubbery has been wisely eliminated.

In sketch number 4 a garage has been added to the same general group used in 3. The first try resulted in giving this garage as much attention as the house. As revised, attention has been brought back to the house by changing the direction of light, redistributing the values, introducing some dark foliage at strategic points, and using the direction of shadow lines to carry the eye where it is wanted. See if you cannot follow the process through and discover the reason behind each change. Then recompose the whole group in a different way. The last pair of sketches merely calls attention to the improvement that may be made in a "two value" composition by adding a middle tone. The grays give the forms more solidity and hold the whole thing together. This would be even more evident if the drawing were made at larger scale.

PRELIMINARY THOUGHTS

In making any kind of a picture, obviously the first thing to be done is to establish its dimensions. Most pictures are rectangular and rectangles have an infinite variety of possible shapes, which makes the problem sound difficult. You will, however, not have too much difficulty in arriving at a pleasantly proportioned one if you give the matter a little thought. Perhaps at first it will be decided for you by the size of the paper you use. You are likely to find available sketch pads in the proportion of 9 to 12, which is the page size of this book. In any case, you will not go far wrong if you accept this proportion at first. As you develop greater sensitivity to proportion, you can refine the dimensions of your pictures to suit your taste. The nature of the subject has something to do with it, of course, and most landscapes fit well into a rectangle placed horizontally, with its sides in the proportion of about 3 to 4.

Most landscapes take in both earth and sky: in other words, they have a horizon at eye-level, where the distant land meets the sky. The placing of this horizon is important, particularly where it dominates the picture, as is commonly the case. With few exceptions, it should never under such circumstances be placed midway between the top and the bottom of your picture, as indicated in sketch 1, opposite. The most satisfactory results are always achieved with the horizon somewhat below or above the center of the picture, as in sketches 2, 4, and 6.

Symmetry about the vertical axis is also to be avoided. Sketch 3 shows how awkward it is to place the center of interest in the middle and flank it with similar elements symmetrically placed. The two trees and the two hills of the same size and value only succeed in giving the picture a deadly static quality which is unpleasing and lacking in interest. It is balance, not symmetry, which you are seeking. If you will analyze the scenes which delight you most in nature, you will discover that it is always balance tha gives them their admirable quality. Symmetry is only a special case of balance and is best let alone by all but the most skilful and finished artists.

As you look out across the landscape in nature, the earth stretches away before your eyes into the

distance. It may be perfectly flat or more or less undulating, but you are conscious of the fact that it recedes toward the horizon. Various things contribute to this effect — color and value gradations, diminishing sizes of familiar objects such as trees, and the converging of actually parallel lines as they lead away from you. The most powerful of these factors in producing an effect of depth in a picture is the last mentioned. A tree-lined road or the banks of a stream, whether they be straight or winding, lead the eye into the distance as nothing else will do. The artist makes use of this fact by placing such things where they will do what he wants them to do; lead the observer's eye into the center of interest he has planned as the focus of his picture. Observe how, in sketches 4, 5, and 6, the converging sides of the river or the road carry your eye into the distance. You can make good use of this device, as will be seen as you proceed through this book and make more and more pictures of your own.

In general, the "S" shaped element is a more subtle and satisfactory way of producing the illusion of depth in a picture. It avoids the monotony of the straight line and may be used in either the land or the sky. The clouds, too, are arranged in receding planes over your head, and if you will look carefully at the sky you will see how often this receding "S" shaped arrangement occurs. In Sketch 2, I have used it to make the sky go back into the distance as well as to help lead the eye to the silhouetted house and tree.

I have referred several times to the "center of interest." Every picture should have a principal point of focus where the most interesting element or combination of elements should be placed. For best results, as suggested above, this point should occur somewhat to one side of the vertical axis and either above or below the geometrical center of the enclosing rectangle. You will notice how this has been done in sketches 2, 4, 5, and 6, and also in all of the pictures shown hereafter in this book. Learn to look for this center of interest in every picture you see that attracts you and observe how the artist has used the devices I have mentioned here as well as some others to compel the observer's eye to go where he wanted it to go.

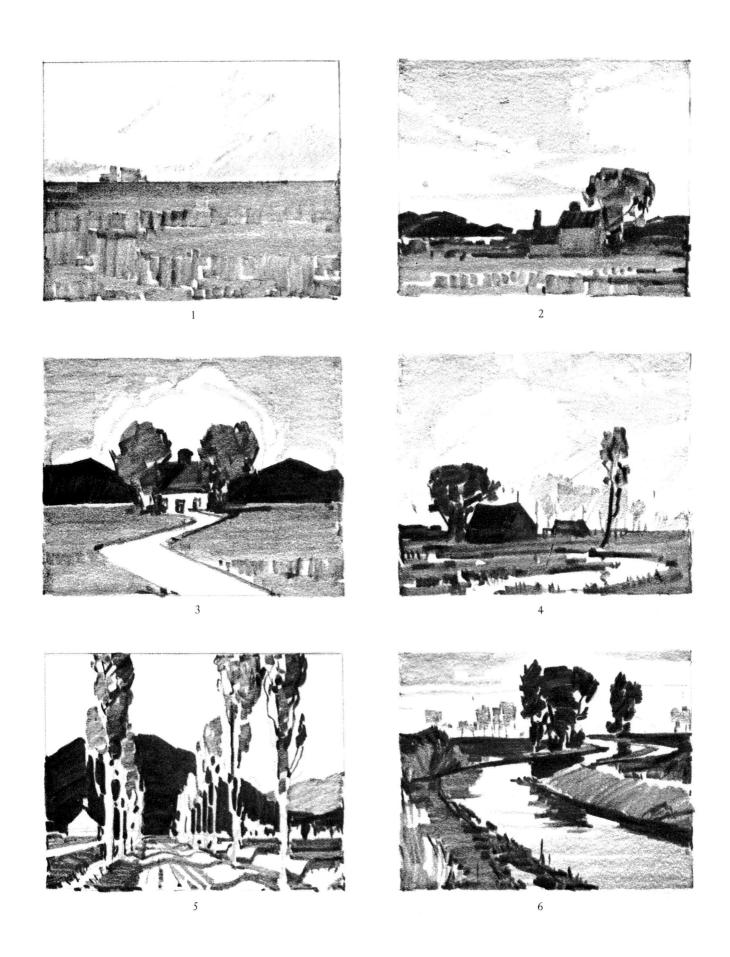

THE LANDSCAPE—BALANCE VS. SYMMETRY

PICTURE SYNTHESIS

Balance has been emphasized as one of the principal desiderata in any picture. It must be present whether the picture is made up of a few simple elements or contains many and complex forms. It may be attained in various ways — but only by keeping it always in mind as you proceed.

One of the useful things to know is that a small spot of dark against light or light against dark can be used to balance a large area of dark or light that would otherwise overweight the picture in its own direction. For example, in sketch 1, opposite, the small gull, properly placed against the large area of sky, has kept the heavy weight of the dark rocks at the left from creating an unbalanced effect. This is shown diagrammatically in sketch 2. In sketch 3, the comparatively small mass of the telephone poles serves to counter-balance the large dark mass of the house and its shadow. Often, when you look at a picture, you may have a feeling that it is overheavy in one direction or another. If you look carefully, you can usually find a place where the introduction of some small intense spot of dark or light can restore the balance.

The beginner must consider carefully, as he plans his pictures, what elements he is going to include and where they are to be placed. Not only must he put the most interesting element at his center of interest, but he must fill the rest of the picture with other supporting elements, each of which must be balanced by something else, somewhere else. Decision after decision must be made, and the result will depend on how intelligently they are made. After a good degree of proficiency has been attained, he will have learned to decide automatically or instinctively what to include and where — and what to leave out.

Some pictures, when analyzed, turn out to be made up mostly of straight lines and rectilinear forms. Others are built out of curves and rounded forms. Sketch 5, and its analysis, 6, show one of the latter type as contrasted with the preceding ones on this page. There is no implication intended that one is better than another — just a matter of pointing out the difference. It is worth noting, however, that there is a certain difference in the mood produced by each of the two types.

Obviously, the subject matter determines the type and, in turn, something of the mood. By selection of the subject you can control to some extent the effect upon the observer. This is a psychological matter. Actually, you will learn, the subject matter, as such, is not nearly so important in picture making as the arrangement of the elements into a pattern — a design, if you wish to call it so. A really well designed picture looks well because of the arrangement of its light and dark areas, of its forms and its lines, into a well balanced and interesting ensemble. Thus, the abstraction, which contains no recognizable objects, may be a satisfying work of art. But we are not concerned with abstractions here; only naturalistic pictures, which are intelligible to the average person the world over.

Returning now, for the moment, to sketch 3, your attention is called to the way in which the lines of the design pattern cause the eye to go to the center of interest — the little house, near but not at the middle of the picture. Although the house at the left is nearer the eye and at larger scale, all its lines seem to converge upon the smaller building. Even the shadow leads the eve where it is wanted. There are some strong horizontals, however, which would carry the eye away to the right if they were not interrupted by the vertical telephone poles, introduced for that reason. The small pole at the left not only helps to assure us of the reality of the telephone line but is carefully placed to help frame the center of interest, to continue the line of the foreground roof, and to break up the sky area. In sketch 5, though the forms are rounded, the underlying principles are the same. The little barn is the center of interest, the eye is led to it by the lines of the fence and the curving road and held there by the strong contrast in value of the white silhouette against the dark hill. The telephone poles not only keep the eye from escaping to the left but their crossbeams serve as a balancing accent for the heavy dark of the hill. It is fun to analyze thus a picture already drawn. It is more fun to plan other pictures so that they will not only depict something but be in balance and have good design.

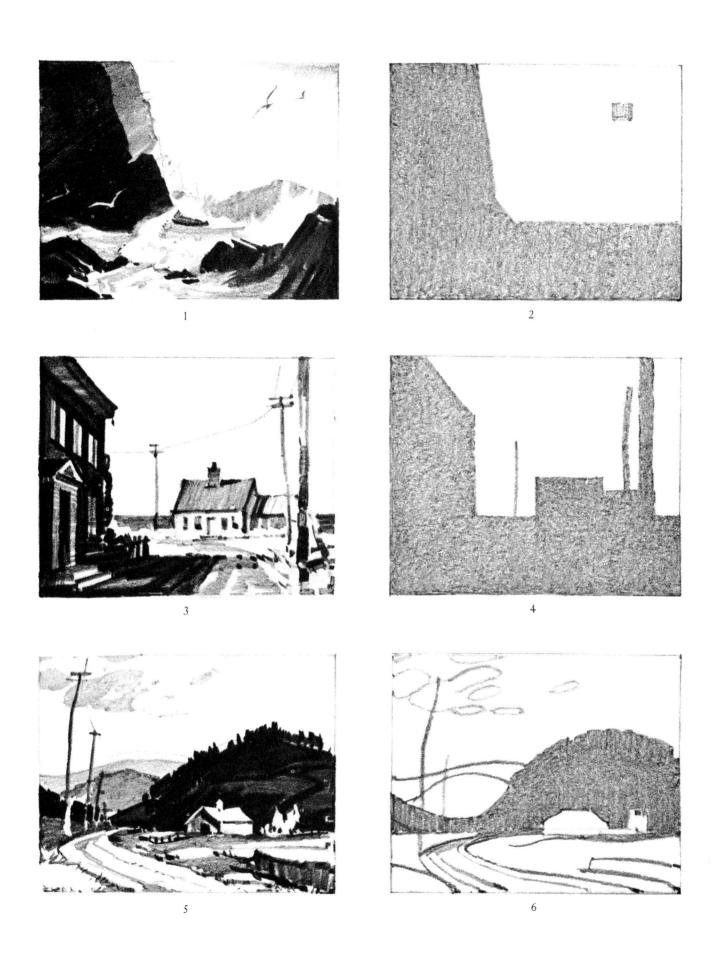

BALANCE—ANGULAR AND CURVED FORMS

VALUE ARRANGEMENT

Most landscape pictures consist — to use the terms often heard among artists — of a foreground, a middleground, and a background. While the relative areas occupied by these varies, the beginner cannot go far wrong if he makes them about equal. There is no rule about this, however, and good pictures will be found in which the proportions of these three areas are in practically every possible relationship.

Most pictures also contain three principal values, or grades of darkness and light. Particularly if you half close your eyes in looking at them, you can see the light areas, the dark areas, and the medium or gray areas. All variations from these seem to merge into one or the other. For purposes of analysis, therefore, we may assume that the three are all there are.

In the sketches across the page I have shown the six possible combinations of these values as arbitrarily assigned to foreground, middleground, and distance. This is not the way you will find them divided in all pictures, of course, but the device produces a set of six possible ways to make simple and often pleasing designs. In nature you will find them all at different times of the year or day, given the right lighting conditions. No one can say that one is better than another for the picture you intend to make, but, just as with the type of forms depicted, your choice will influence the mood produced.

In sketch 1, opposite, a cloud shadow may have fallen over the foreground, yet the sky is bright and the hill is receiving enough sunshine to give it a gray tone. In sketch 2, it is perhaps early in the morning or late in the afternoon with the hillside completely in shadow. The sky is again bright and there is enough reflected light to make the foreground count as gray. The conditions in sketch 3 suggest the sun behind the observer, lighting up the foreground brilliantly and making the wooded hill appear gray against the dark sky which might indicate an approaching thunderstorm. Next to it, in sketch 4, we again have a brightly lighted foreground, this time silhouetted strongly against the hill over which there is a cloud shadow. The sky is rendered gray which may be the blackand-white interpretation of its blue tone, or possibly a mass of clouds. In sketch 5, the sun may be low in the sky so that the foreground is in the shadow of a hill behind the observer while the sunshine lights up the hillside beyond the house. Here, we may imagine that the sky is actually gray with cloud and we make it so. The last of the possibilities appears in sketch 6, with a stormy sky beyond the hill which is in full sunshine, while a cloud shadow grays down the foreground.

You have undoubtedly seen all of these conditions in nature from time to time, but have probably not stopped to analyze the six possibilities in this way. Hereafter, you will probably keep them in mind in planning your pictures and if you do you will find that you will have greater control over the effects you wish to produce.

Please do not assume, from what I have said, that these are the only ways values are divided in pictures. As suggested above, there are many other ways in which the three main values can be interestingly distributed in patterns that may be beautifully complex. Darks may be in both foreground and background; lights in middleground and distance; grays in all three divisions and so on. You will learn to arrange them with greater variety as you proceed.

In most of the Picture Plates to follow, I have indicated at small scale the division of the three principal values as I have conceived them to give me the best design for my pictures. In some cases I have shown the same subject as it would be with values changed about. It is good training for you to experiment with little sketches like these so that you can gain understanding and control over what you undertake to draw. Many times you will find that you can make a more satisfactory picture by reversing the value relationships from what you actually see before you. But it must be done with full consciousness that the reversed values are possible in nature under different conditions. There must be truth in what you draw or it will fail to satisfy the eye. So never miss a chance to study and analyze nature as you go about your travels through the country and even along the path you follow daily on your way to and from work or play.

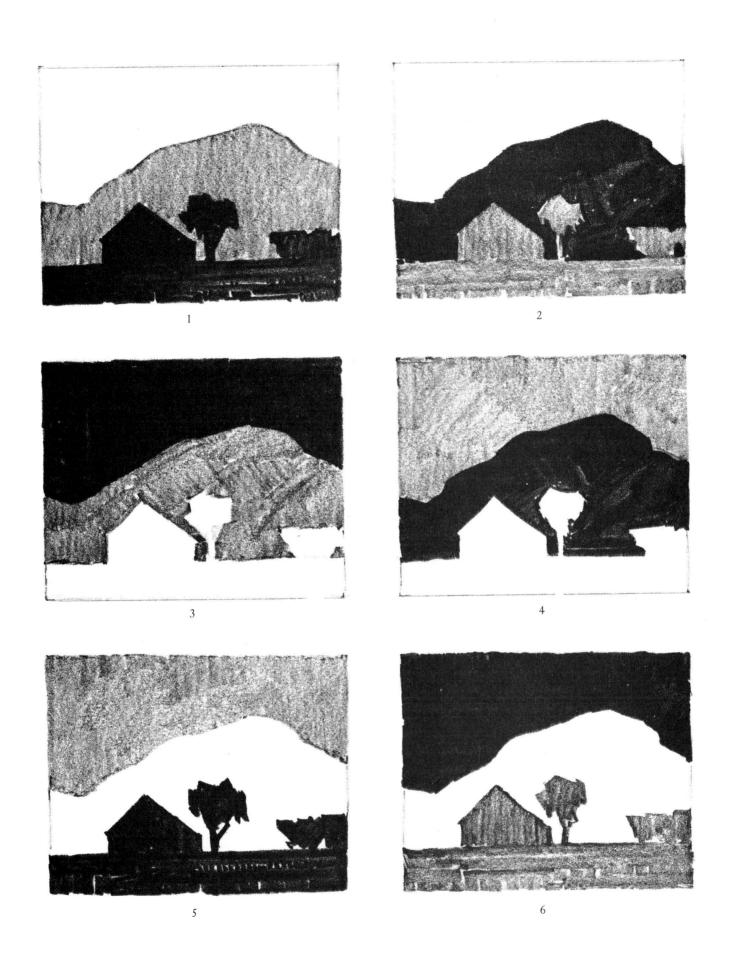

FOREGROUND, MIDDLEGROUND, BACKGROUND

PLANNING A PICTURE

Now we come to the planning and carrying through of a finished pencil picture. Let us assume that we are at the beach and that we are attracted by the picturesque quality of a lighthouse we see along the shore. There are many things on and near the beach out of which we can easily build up an interesting design. There are likely to be rocks and boats and bits of driftwood, and pools of water left by the tide, and various seaside cottages or small buildings. Even if the point of view we choose from which to sketch the lighthouse does not include all of the things we want to use in the finished picture, we observe and remember their characteristics.

After we have laid out our bounding rectangle, we select a high horizon level so that we can include more of the beach than of the sky. We then place the principal object of interest, the lighthouse itself, a little to the right of the middle of the rectangle. Now we begin to introduce lines and elements that will lead the eye toward the lighthouse. Some rocks receding away from us along the landward side of the beach, some more rocks jutting out at right angles to the shore near the lighthouse, a pool of water near the high tide mark, a row of old piles thrust into the sands to provide mooring posts, with a couple of boats conveniently aground at strategic points to contribute to eye control, — these are used to build our linear diagram as in sketch 1.

Most of the lines thus introduced converge on the object of our principal attention, which is what we want. We notice, however, that the horizon and the horizontal line of rocks tend to lead out of the picture as well as into it. To stop this outward movement, we put a big mass of rock at the left to terminate the ledge, and to make things sure we turn one of the little craft into a sailboat, with a vertical mast cutting across the horizon. Now we have perhaps too much at the left of the picture, so we introduce a small house on the right for the lighthouse keeper to live in. All these things are natural and plausible and we are within our rights in moving them around to contribute what they can to our design. Our diagram now looks like the sketch at 1.

The next step is to decide upon the arrangement of

the principal values. In order to make fullest use of the receding line of rocks at the right, we assume that the sun is coming from that direction. This assumption gives us a good dark area, reinforced by a gray shadow which also will help to lead to the center of interest. The rocks extending horizontally will also have some good dark surfaces where they are in shadow. To increase the strength of this horizontal movement we assume a good dark value for the sea beyond. The shadow sides of the boats, balanced by some dark foliage introduced to silhouette the lighthouse and accentuate its importance, complete our principal dark value. Grays are next to be indicated and with them we model the forms of the rocks to give them solidity. We also make the shadow sides of the buildings gray, remembering that they contain reflected light from the beach. This gives us our value diagram at 2.

We can now proceed to lay out the final sketch at full size, following the diagrams which have given us our plan of action. Working at this larger scale allows us to modulate the surfaces within the range of each principal value, allowing for the play of reflected light from the beach in the shadows and for the slight grays in the light areas. We also define the details of the boats, the mooring stakes, and put in a few bits of grass and driftwood where we feel they are needed. In doing this we are always conscious of the contribution each item may make in our entire design. Nothing should be added that does not have a function in the picture. The imagination of the observer will fill in the gaps. We give him only the essentials that convey our idea. At 3, 4, and 5, I have suggested some other beach scenes, following the same principles of building up the design by means of line and value arrangement. At 3 the center of interest is some bathers playing at the water's edge; at 4 an old picturesque hulk half buried in the sands; at 5 a foreground rock and its reflection in a puddle. In all three the line arrangement leads the eye and holds it from escaping; in all three the values are arranged to give the greatest contrast at the vital point as well as to balance each other and keep the center of gravity where it is wanted.

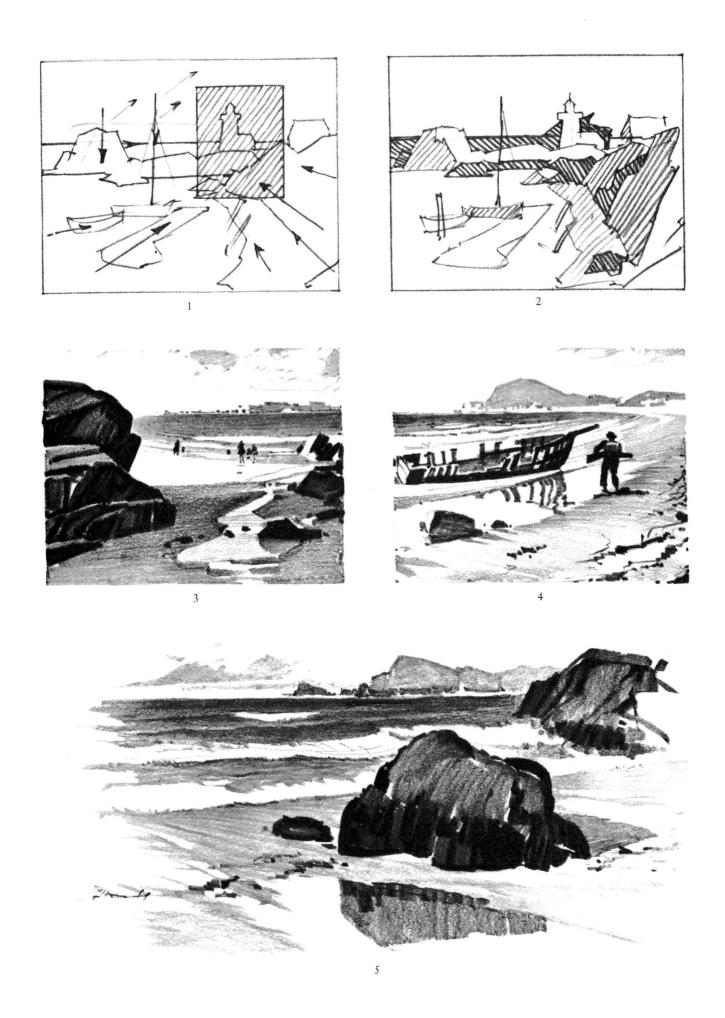

THE BEACH—CENTER OF INTEREST

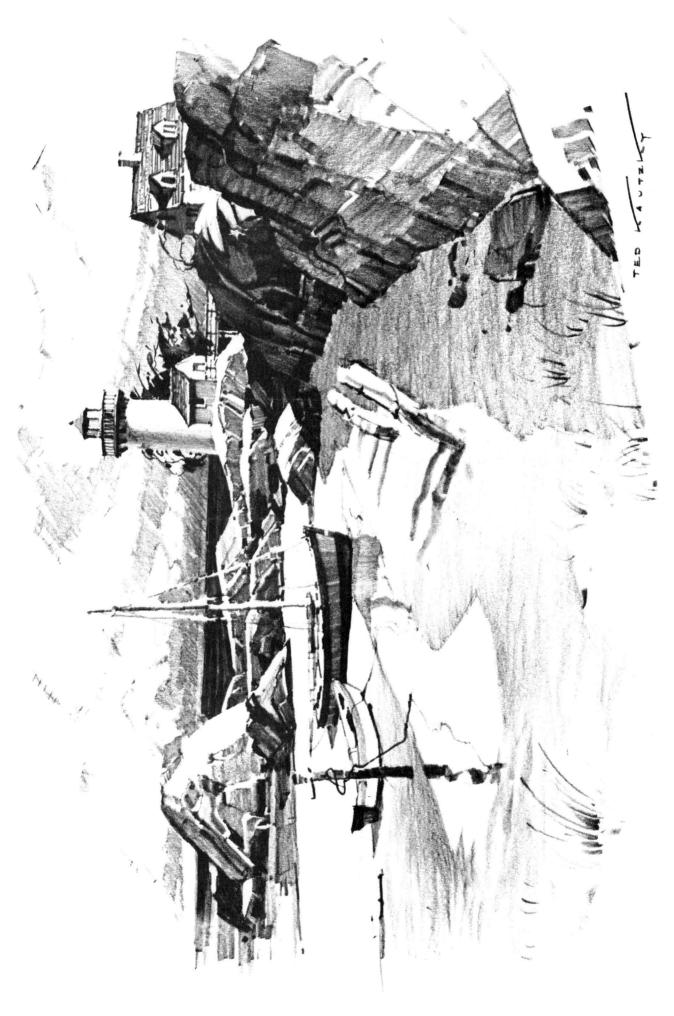

SEACOAST REFLECTIONS

Now we will try another scene along the shore, with a fishing boat as the principal item of interest. We see the boat, moored in midstream, one sail already lowered as the men move about tidying things up after their day's work on deep waters. We are standing on high land away from the shore and looking down on the scene, so we choose a high horizon. We decide to place the center of interest to the right of center in our rectangular frame and to sketch in the rocky bit of shore with the low-lying promontory beyond so that they will enframe the focussing point. These two strong lines leading outward and to the left would, however, carry the eye away, so we decide to have a strong counter movement toward the boat in the form of a little pier, jutting out from the rocks. To strengthen this counter movement, we emphasize the little point of rocks hooking around the cove beyond the pier. A low lying island, off shore, also helps to close off the temptation for the eye to escape. Our plan in line now looks like sketch 1. As to value distribution, we decide on a dark foreground to give our picture a firm base, a light middleground to afford a sharp contrast for our boat which will silhouette against it, and a gray distance to form the upper closure. We allow for some strong lights in the foreground to break up its solidity, and imagine the sun coming from behind us and shining upon the rocks to give us this opportunity. Refer to sketch 2.

From there we can proceed to work at final size, sticking to the general scheme but giving greater play to our fancy in putting in details as before. A little boat house on the pier, some small craft moored alongside and in the stream, patches of grassy growth over the rocks above the tide mark, and reflections in the water will give you ample opportunity to exercise your skill in delineation. The direction of every stroke, the position of every form should be calculated to lead the eye where you want it to go. The degrees of contrast in each part of the picture should be used to emphasize or subdue its importance.

At the bottom of the following page, sketch 5, I have drawn the same scene at a smaller size than in the final plate that follows. This is to show how the

same picture can be accomplished with much less detail. The amount of detail you must put in depends on the size of your picture in relation to the size of your pencil strokes. It is well to practice drawing at several sizes to gain versatility.

In drawing boats and other objects on or beside the water, the question of reflections enters in. Properly drawn, reflections can add greatly to both the interest and the realism of your pictures. Often, however, we see drawings which fail to convince, just because the reflections are awkwardly drawn or incorrectly interpreted. In sketches 3 and 4, opposite, I have sketched a couple of scenes in which the reflections play an important part. By their use, the surface of the water is made to seem very real, almost wet, in fact.

Now, everyone knows something about the laws of optics and all are familiar with reflections as seen in a mirror, at least. The surface of the water acts just as a horizontal mirror. When it is absolutely flat and unruffled it is exactly like a mirror, reflecting a faithful inverted image of objects upon it or adjacent to it. Seldom, however, is the surface of water in nature unbroken by ripples or small waves caused by the wind or by the effect of tides and currents, or by the passage of boats or birds or other things through it. This roughening of water surface has the effect of lengthening out the reflections, extending them towards the observer, and breaking up straight lines into zig-zags as the surfaces of the waves tilt one way or another.

Here comes in the matter of perspective. As you look across the water you are of course looking down on it at varying angles, depending on how far you are looking. A given angle of vision radiating from your eye will include more or less of the water's surface according as to whether you are looking far out from shore or near to where you are standing. Thus your glance will take in many more little wavelets in a given vertical distance far away than it will close by, and you will have to put down more little zigs and zags for the more distant reflections than you do for those near at hand. I have done precisely that in these two little sketches and the water surface is kept in proper receding perspective thereby.

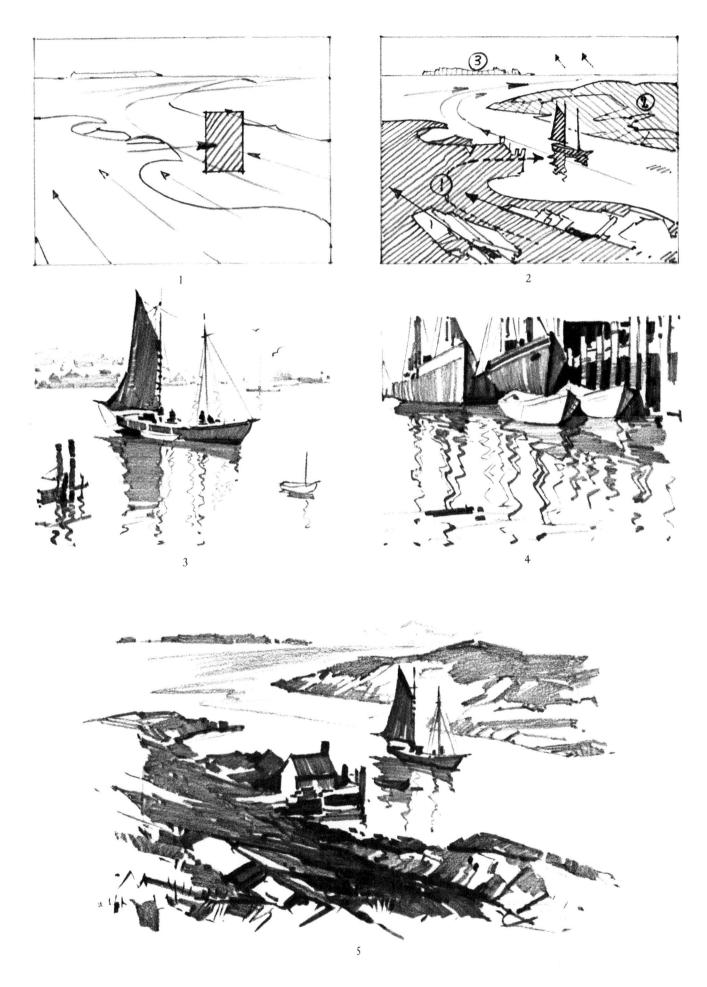

ALONG THE COAST—PERSPECTIVE

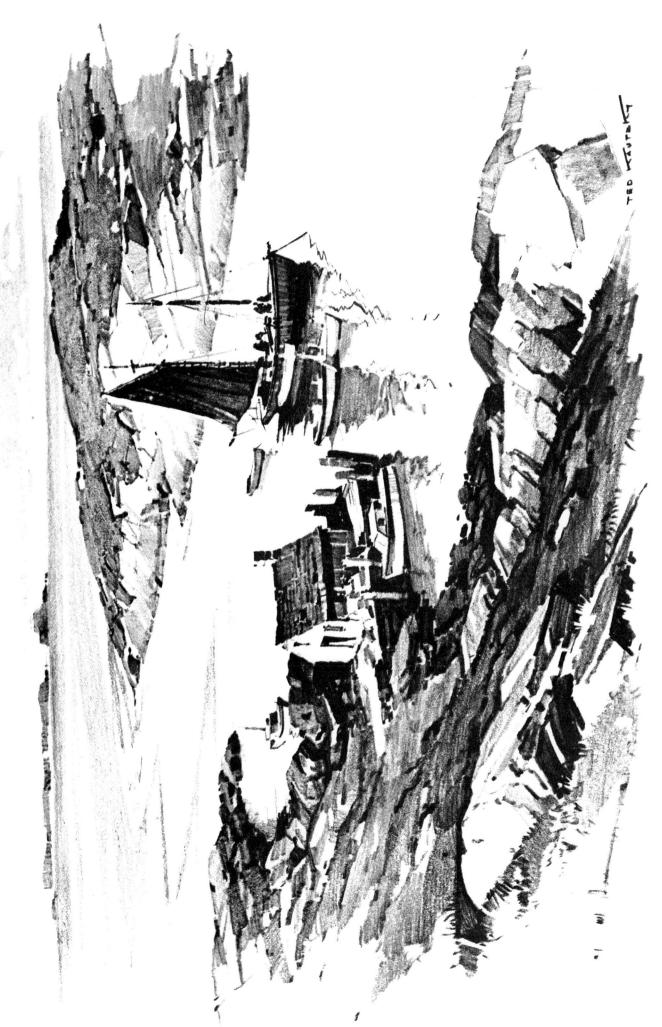

THE FISHING PORT

Boats are always fascinating and picturesque subjects to draw and the waterfront of any seaside or lakeside town is full of interest for the aspiring picture maker. We are here undertaking to do a sketch in a busy fishing harbor. We stand upon a wharf and look out across the water to other piers where shipping of various types is tied up. Our attention is caught by two business-like looking craft at the next wharf, where they present a sparkling silhouette against the shimmering waters farther out, and against the sky. Across the way is another dock, with a cluster of miscellaneous ships grouped alongside.

We decide to make the two fishing boats the principal subject — the nearer one the most important, with the other giving it support. We see that by placing them slightly to the left of center we will be able to use the group of boats beyond as a means of leading the eye and we also see that by including the end of the pier upon which we stand we will have a strong foreground element to hold down the right side of the picture and prevent any escape for the eye in that direction. The projecting ends of the two piles which act as mooring posts form a powerful barrier. Though they are actually vertical, we tilt them a little to avoid stiffness as well as to divide the picture more interestingly. Our scheme of principal lines is now shown in sketch 1. Note how the group of boats at the pier to the right stops the eye from following the movement set up by the mooring posts and turns it back to the center of interest.

For values we decide to make the nearest boat and its reflection the darkest. The other boat we will make a little lighter and will balance it by making the pier end about equal. A third gray will be used for the pier buildings and the more distant ships. This makes the diagram as in sketch 2.

Just for fun, it might be interesting this time to make a preliminary study at about half the size of our final drawing. I have done one at the bottom of the page, sketch 5. By doing this we can verify our earlier judgment about the placing of the different elements and experiment with the introduction of details. When we have finished with the study we can perhaps see some slight changes in position or value that can be made to advantage in the full size

job. As a matter of fact, I did make some slight but important changes in boosting the scale, and if you look sharply you can find them without much trouble. I am going to leave it to you to figure out what I did change and for what reason. You should know enough by this time to decide for yourself. Of course some of the changes consisted simply of putting in greater detail and modulating values to define the forms.

Many people have difficulty in drawing boats convincingly. They either produce awkward and untrue shapes or make them fail to sit properly on the water. I, myself, used to have this trouble until I thought more about it and learned a little trick. In sketch 3, here, I have indicated a boat as you would see it in looking right down on top of it and as it would appear from the side. These views you practically never use. Usually a boat will be viewed from an angle and looking slightly downwards. I have shown one in this position too. Dissecting this little diagram, we discover that the top edge of the hull, followed around, reduces itself to a flat, slightly bowed figure eight, and that the stem and stern occur at the highest points on the side of the eight, a little way from the ends. If you will first draw this figure eight, therefore, it is a simple matter to complete the boat, and it will look real. Easy, isn't it? Note that in the same little sketch of the boat I have indicated with arrows the direction of the strokes used to model the sides. If they are made to follow the direction of imaginary ribs they will help to express the rounded form of the hull and will make your boat convincing. The reflection on the water should be at least as tall as the boat itself; in other words, B should be greater than A.

Where there are too many vertical lines in reflections along a waterfront, the effect of drawing them all in might disturb the essential horizontality of the scene. To counteract this effect (see sketch 4) we have only to follow nature and introduce some narrow strips of light value, cutting across all the verticals and changing the emphasis of line direction. Strips of this sort are visible on the surface of any harbor. Observe that I have not made them parallel, and that they are closer together and narrower as they recede.

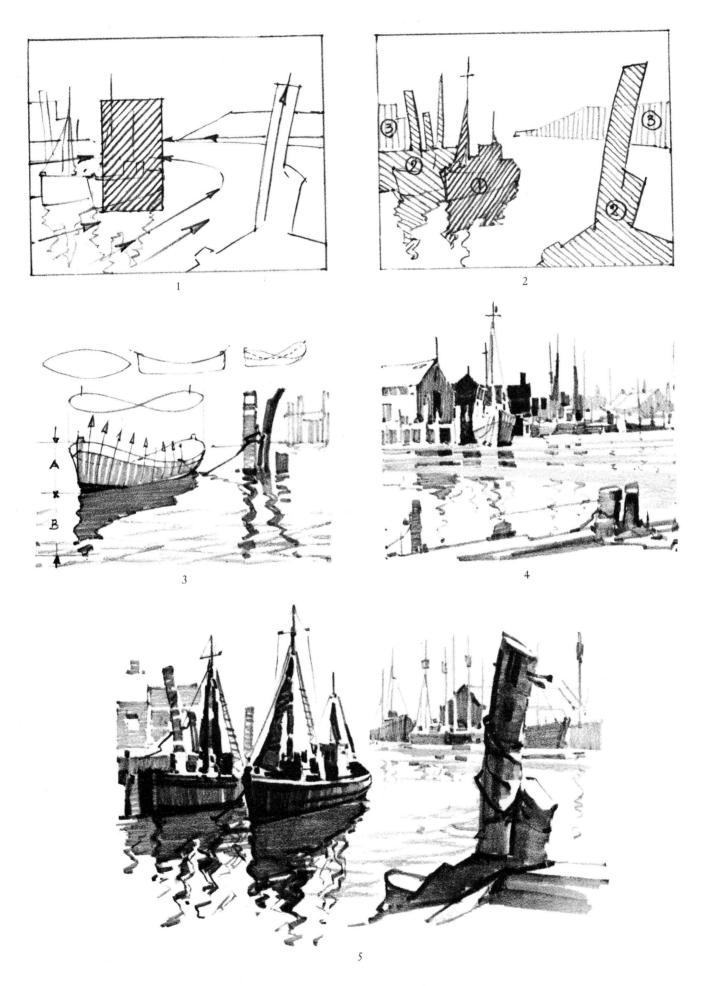

BOATS AND WATER

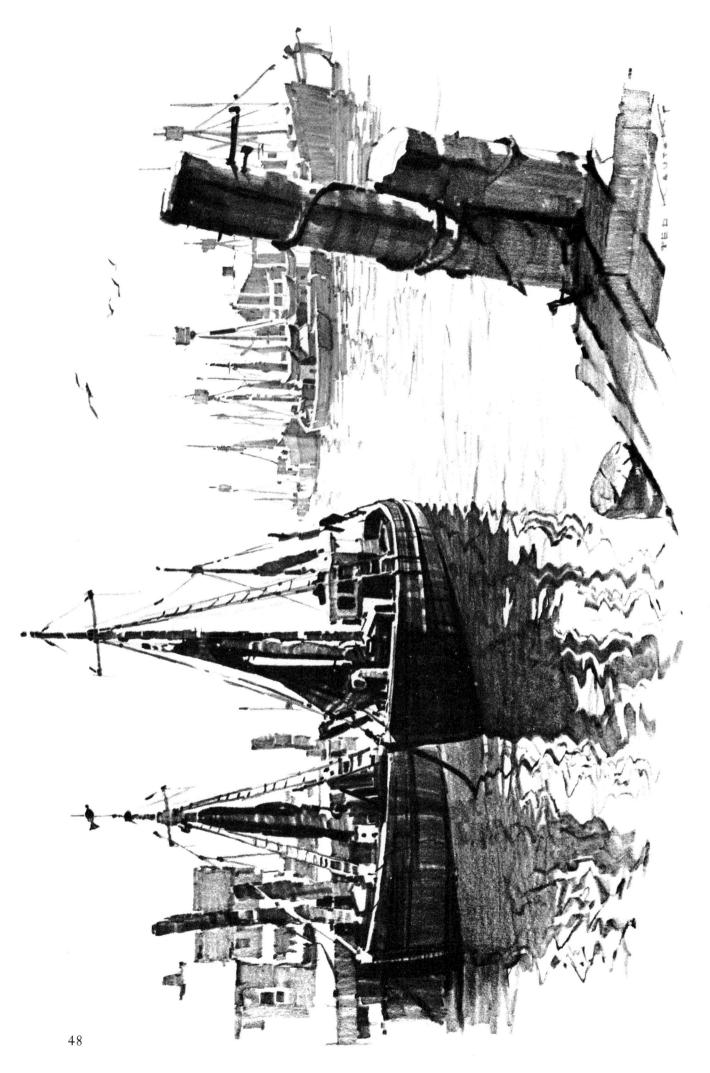

THE USE OF CONTRAST

Standing on the fish pier one day in a little seaside town, we notice a striking scene. It is low tide and a great dark triangle of sail belonging to a fishing boat moored alongside projects up into our eye level. Some white gulls flying around in the sunlight silhouette themselves sharply against the sail as they soar to and fro looking for scraps of food. The contrast between the bold dark area of the canvas and the graceful, brightly lighted birds suggests a sketch.

We take up our position where the sail will be almost in the center of our picture but a little to the right, and where we can see the fish house on a neighboring pier to the left and some sails and rigging beyond our boat on the right. This will give us two balancing elements with plenty of directional lines that can be accented to lead the eye into the center of interest. The pier upon which we stand is suitable for a foreground, its edges vanishing away from us towards our picture. A dory lying upon it, presumably hauled up for caulking or repairs, is over to one side, but we see in it a chance to get added interest and so move it over in front of our sail in a position that will, we think, help our design.

Now we have our plan all nicely arranged as in the diagram, sketch 1, with our strong upward diagonal of the sail well counteracted by the sloping roof of the fish house in opposition to it. The spars and rigging on the other side are also useful to break up the verticality of the masts and lead the eve downward from the right into the point of focus. We decide to place a white gull against the sail at precisely the point where the prolonged spar and roof plane would intersect. There are plenty of other gulls around and we can arrange them so that they, too, will guide the observer's glance, step by step, in a wavering but inevitable course to our chosen center. We do not put in too many gulls and we are careful to space them unevenly and give them various soaring positions.

Our value arrangement is almost dictated for us: the intensely dark sail in the middle, with three balancing grays around it and a light sky and foreground. Now we can go to work on our half-size or final, whichever we choose. In working up the final drawing we use our ingenuity, as usual,

in introducing appropriate detail. We consider carefully the size and relative positions of our gulls. One we place so that its wing tip crosses the edge of the sail. Notice that where this occurs the wing is light against the sail but dark against the sky. That is the way we see things in nature and we are telling no lies in drawing it that way.

The break in the sharp edge of the sail softens it and suggests sparkling sunshine, so when we put in the juicy black strokes to render the whole sail we break its edge in other places and leave a few small patches of light to increase the effect.

Gulls occur so often as incidentals in seaside pictures that it is worth while to take a little time to watch them soaring and darting about and alighting on the rocks or on boats or upon the water. They are masters of flight and move about with supreme grace and precision. You can memorize and jot down some of the interesting characteristic positions they assume in the air so that you will be ready to insert them in some of your drawings without waiting for them to come and pose. I have indicated a few in sketch 3, opposite, and have used some as the principal subject in sketch 4. Note their tremendous wing-spread in relation to the size of their compact bodies. It is fair and safe to exaggerate the length of wing a little, rather than the opposite, since in flight they give the illusion of being longer than they are. Note also the bracket-shaped double S-curve of the wings when you see them head-on. This fact is an aid when drawing them from memory. If you will remember their fundamental proportions and structure, you can draw them, thereafter, in any position, sight unseen.

This chapter is supposed to deal with contrast and its uses, but as you may have noticed I have so far said nothing about it except to refer to it from time to time in passing, as we proceeded to analyze the picture we were making. Yet you must have felt its importance. Contrasts in black-and-white work may be of several kinds — of value, of line, of size, of shape, of spirit. They increase or decrease emphasis and interest throughout your pictures, according as they are sharp or delicate. The artist is always using contrasts to help make you feel what he felt as he set down his impressions.

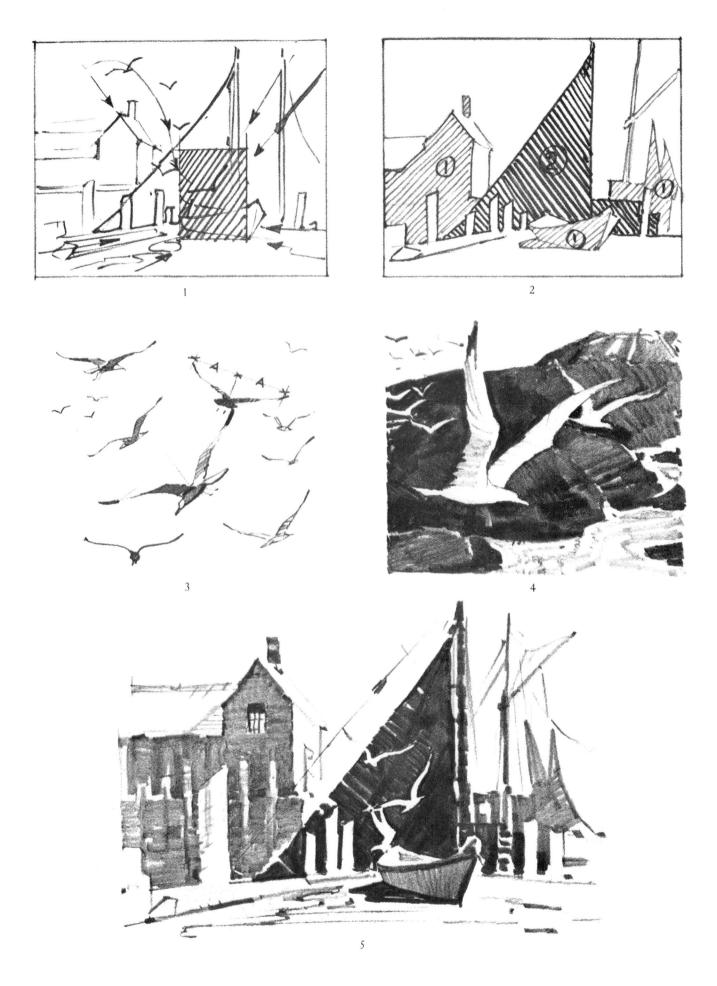

LINE OPPOSITION—GULLS

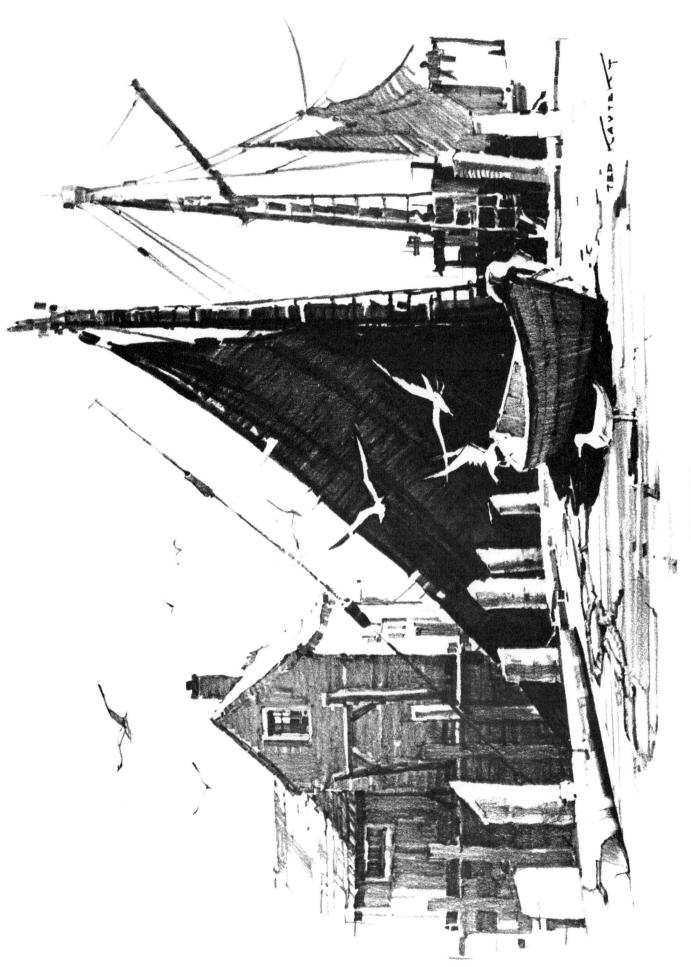

COMPELLING THE EYE

At the risk of seeming to prolong unduly our stay at the seaside, I am going to devote one more lesson to a waterfront subject. In it, we will try to incorporate some of the things we have already learned and perhaps discuss a few points not touched upon before.

We will take as our picture material a very famous fishing pier in Rockport, Massachusetts - so famous that it is known far and wide among artists as Motif Number One. Practically every painter or sketcher who ever came to Rockport has done at least one picture of this subject and there are some who have made many. Its attraction is that it is picturesque from every point of view and that the atmospheric and lighting effects are constantly varying with sun and season. We will say nothing here about the color, for we are working with black and white — but there is a rich range of values and a treasury of geometrical forms and patterns here to reward the searcher after beauty. We happen to choose today a view from down on the rocks near the base of the pier. We are intrigued by the strong, dark, receding shadow side of the pier as a background for the ever-present gulls which make patterns against it with their wings. Our problem — if we have a problem — is to prevent the powerful vanishing lines of this pier from forcing the eye always out at the left side of our picture. But we have countering influences. First, the rocks along the shore can be used to build up a strong up-sloping movement to the right. Then the fish house, topside, with its reflection in the water, can be used as a weighty vertical element which anchors the middle of the picture pretty firmly. It is aided by the many vertical piles along the pierside, which break the long sloping edge into many parts and destroy its dominance over the eye. Finally, lest there is still a tendency to the left, we can introduce a couple of mooring piles on that side as a final barrier to any escape. Now we can group our gulls so that they will compel us down from the sky, undulatingly, to the spot of our intended climax.

We choose to make our deepest dark value, as shown in the little diagram, where it will give the most brilliant silhouette for our birds, and to shade it off into gray toward the end of the pier, which will merge with the fish house on top. The mooring posts will be gray also, which is strong enough for their outlying position. The foreground rocks, bathed in bright sunshine, will take some good dark shadow to help hold attention at the center as well as to express their form.

In rendering our final, we have opportunity to think well about the play of reflected light within our shadowed areas, for it is thus that we can model our forms and give them solidity. We particularly study our gull formations to achieve variety and interest of pattern and to be precise with their sharp and expressive silhouettes.

Even if the piles along the pier were evenly spaced, we would not make them so, for it would be too monotonous. Rather, we try to space them so that they have an irregular rhythm. We even suppress one where it comes behind the gulls and would break up their pattern.

I have made two little sketches opposite of some piling along a stone pier and under a wooden one. In both of these I have deliberately departed from regularity in the spacing. For whatever reason, it is lacking in interest to show evenly spaced objects running across your picture, or any substantial part of it. You are not bound to draw exactly what you see before you in such an instance for you know perfectly well that you have often seen similar scenes where the course of time has worn down and broken up the original geometric perfection of spacing. Use your artistic license: you have one, of course!

When looking through a pile-supported landing, as at 4, you can advantageously use the more distant piles, which are in full shadow, to silhouette the foreground piles. (You can do the same thing with trees in a woods, as will be shown later.) Anyway, it is more satisfying pictorially to shift these and other details around to serve your purpose. Notice that I have made the spaces of distant light seen between the piles all different. I could have made them all the same, and how deadly it would have been, even had it been true! You must have learned by this time that the artist continually uses common sense in arranging his lines, values, forms, and contrasts — and he thinks before drawing. You can do likewise!

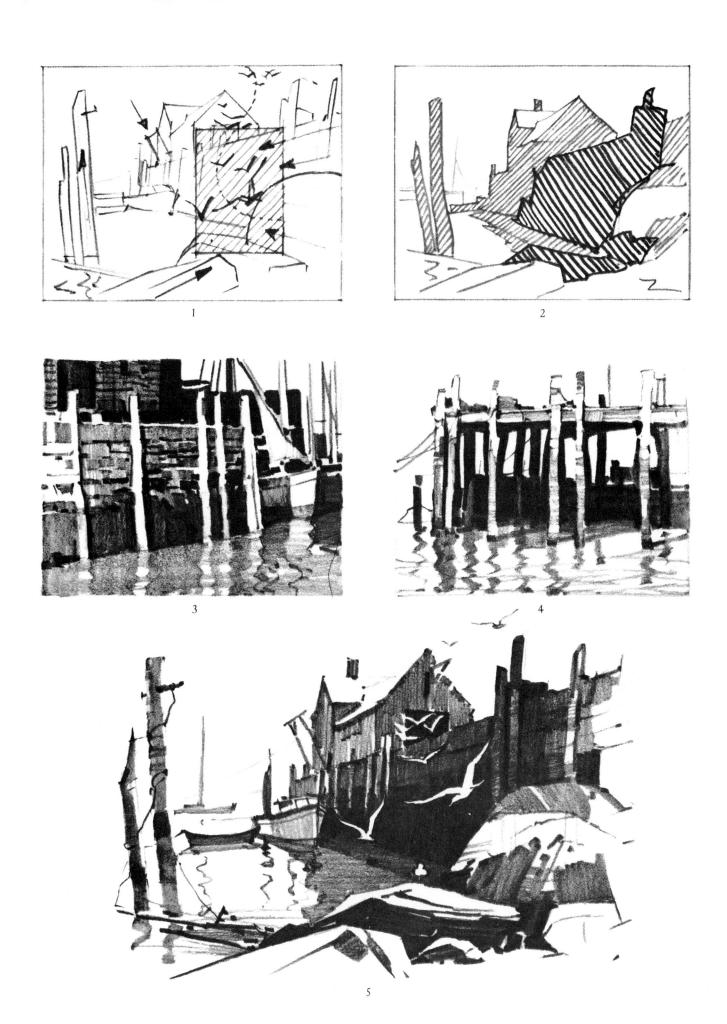

MORE WATERFRONT TOPICS

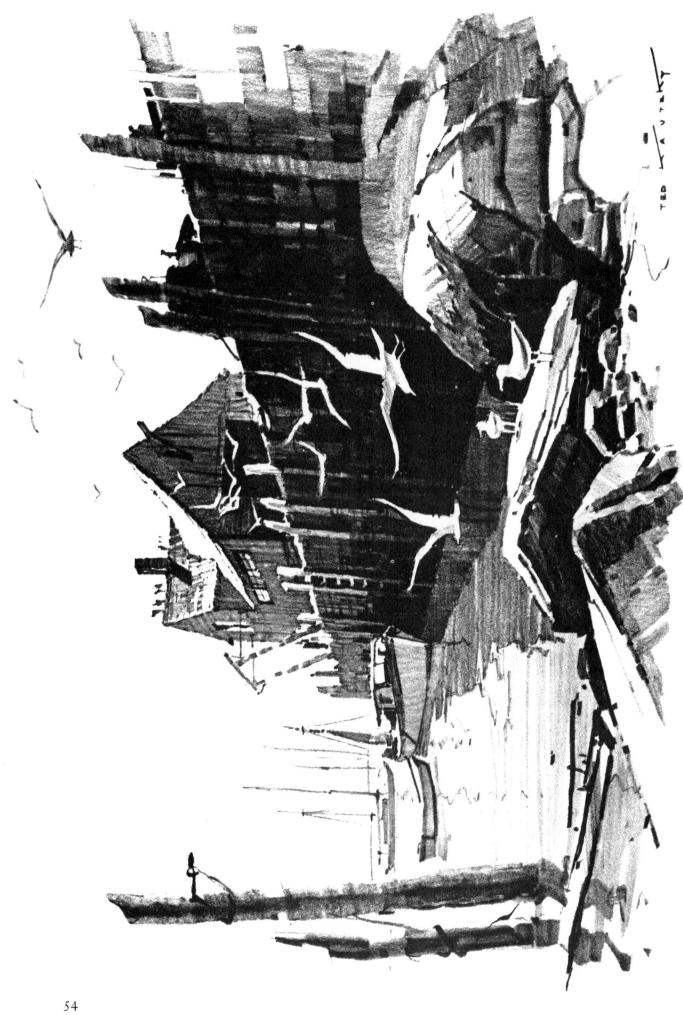

THE VILLAGE SCENE

Perhaps it will now be refreshing to get away from the water and see what we can do with scenes on dry land. Let us go to some little village, perhaps in New England, perhaps elsewhere — the principles are the same. We walk around the village streets until our eye is caught and held by a pair of charming cottages. Why can't we pass along the charm to others in the form of a sketch — a picture, I should say?

We lay out our rectangular frame and decide to put the little houses to the left of center, so that we can take full advantage of the long horizontal tree shadows that lie across the roadway. They will be effective in directing attention where we want it. The street is dotted with old elms, and we can use their arching forms to enframe the view and provide a lacy pattern overhead. A low horizon lets us include the foliage.

The two houses, the two trees, and their shadows are almost enough in themselves to make our picture, and our linear diagram appears promising as in sketch 1. Some more houses and trees up the street can be used to fill in any void and keep the eye from wandering out in that direction. Filling in the value diagram, at 2, we put the principal dark over roofs and shadow sides of the houses, and extending in radiating strips on the limbs of the trees and the shadows on the street. A somewhat broken up gray mass in the background and in the hanging clusters of foliage will complete an arrangement in which the eye is both properly directed and held in place.

Going now to full size, we render the houses with plenty of sparkle from the sunshine streaming across under the branches. We have assumed a low sun in late afternoon or early morning.

By this time you have probably observed for yourself, if I have failed to point it out specifically, that it is well to put the greatest amount of clearly indicated detail and the sharpest contrasts of dark and light within the center of interest. As we get outside this area, we can make fuzzier detail and softer contrasts. This, again, is the way we actually see things in nature, and to draw them thus increases the likelihood that the eye will respond to the suggestion and go where it is wanted.

The long line of the sidewalk and picket fence would tend to lead the eye away from the center of interest if it were allowed to assert its presence without interruption. I have been careful to break it up in various ways by crossing it with the heavy street shadows and merging portions of it into the horizontal bands of sunshine. The verticals of the tree trunks and house walls also help in this purpose. The two little figures are placed so that they continue the vertical movement of the light facade of the house they are passing and so form another interruption to the fence line. There is a slight advantage in having them walking towards the center of interest rather than away from it. This is a useful point to remember when using figures, though it is not of particularly great importance in this case where the figures are small. Wherever you do use figures, use them for a purpose and not just aimlessly or because you like to see people in a picture.

At 3 and 4, opposite, I have made two variations on the same theme. The first one is the same in content as our main subject, but the lighting has been changed, with the sun higher in the sky and coming toward the observer. In the second, I have left out the sheltering trees and made the houses fill the rectangle. Here, the sloping lines of the roof gables are important in setting up opposition to the continuing line of the fence and sidewalk, which would otherwise tend to lead your eye out to the right. Perhaps it would have been better if I had inserted a few countering strokes in the lower right hand corner, representing a shadow or a rut in the street, to direct attention upward to the left where the picture interest lies. However, I left things as they are.

At 5, on the facing page, I have made a picture out of a couple of larger houses and a majestic tree, shading one of them. Here, the front door and facade of the nearer house form the focus of interest. The strong dark of the adjacent house acts as a contrasting background which is kept from being too solid and overpowering by breaking it up with foliage and reflected light. Notice how occasional breaks in the shadows on our main facade give sparkle; also how the shadow strokes follow in general the direction of the sun's rays.

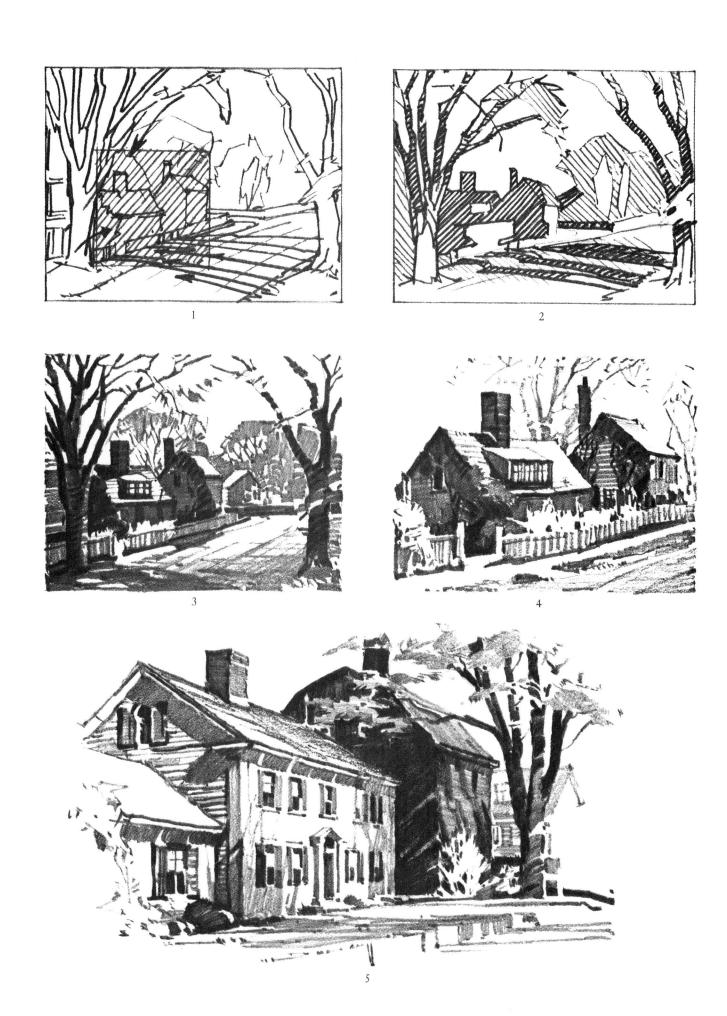

TREE-LINED STREET

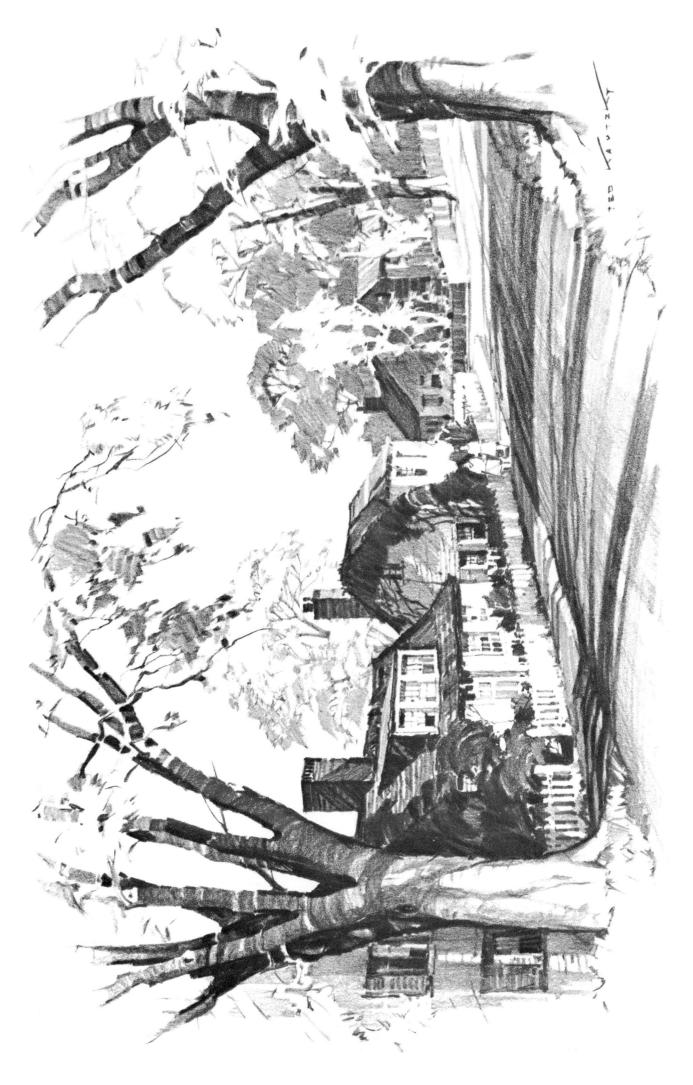

THE CHANGING SUN

The possibilities of the village street as a source for picture material are almost limitless. There is always, or almost always, a vanishing vista with a variety of houses in sight on both sides to give a rich play of architectural forms. Commonly, there are trees spaced along at more or less regular intervals, creating interesting shadows and letting the sunlight strike through their branches and foliage in a brilliant display. At different times of the day, the light comes from different directions and constantly changes the aspect of things so that it is quite possible to make several different pictures from the same point of view.

For this lesson, we have chosen to look directly down a straight street, standing a few feet out from the sidewalk on the right hand side. The sun is coming from our left and a little behind us and falls interestingly upon two or three little cottages a little distance from where we stand. The long tree shadows strike across their fronts but the sides shine out brightly and make a geometric pattern. The cottages are to be our center of interest, a little to the right of the middle and low in our rectangular frame.

The trunks and branches of the trees, the shadows they cast across the street and upon the buildings, the mass of foliage of the tree just beyond the cottages, and the dark fronts of the houses across the way give us our darkest value. The street surface, the under side of nearer foliage which receives some reflected light, and the mingled light and shadow on our cottage fronts can best be indicated on our little value diagram as gray areas. This leaves the sky and sunlit portions of the houses for the lightest value. The pattern is intricate and full of dramatic contrasts.

You will have noticed in the line diagram, sketch 1, how strongly the receding street lines and tree shadows lead toward our center of interest and how the arching tree limbs and vertical trunks hold the eye in where we want it. The sloping line of the nearest roof is also a powerful arrow pointing in the right direction. Note, too, the contrasts of curved and rectilinear forms.

Our diagrams and plan of action complete, we are ready to go ahead with our final drawing. Here we call upon all our skill in indicating detail in the architecture, in the tree trunks and limbs, in the grass and flowers. We model the forms with strokes that suggest the contours and where there is a silhouette of light against dark or dark against light we are careful to make our edges clean and expressive. Where the sun strikes the eaves or the dormers or the windows the shadow forms are definitive and we make them so. A few figures down the street stand out sharply against light beyond them and give us a little extra means of accentuating the perspective.

As suggested above, the same scene can make a satisfactory picture with the values completely rearranged. To demonstrate this, I have made two small sketches, 3 and 4, on the facing page. In 3, the sun is coming from the left but toward the observer. In 4, it has swung over to the right. In both instances, of course, the shadows fall differently and the houses are lighted on different sides. Yet the line and value patterns are controlled to lead the eye and hold it in the same area. You should analyze both of these picture arrangements so that you will observe how the principal lines are accented or suppressed and how the darks and grays are made to contribute to the effect desired.

At the bottom of page 45, in sketch 5, I have made a picture in which the center of interest is across a little harbor with a fishing village beyond. The steeple of the village church, lightly silhouetted in gray against the sky, counts as an accent which eventually catches the eye after it has travelled across the water. The arrangement is roughly elliptical, with the foreground elements strongly accented yet forming a sort of frame rather than holding the attention for themselves. You will perhaps recognize, in the middle distance, the familiar silhouette of the fish house known as Motif Number One! Yes, the scene is at Rockport, and this is another of the infinite number of possible views in which this famous little structure furnishes the principal point of focus. Though it is small in area in this view, it is made to dominate the scene by its contrasting value and by the careful arrangement of the foreground objects so that they encircle it and subtly encourage the eye to come to rest upon it.

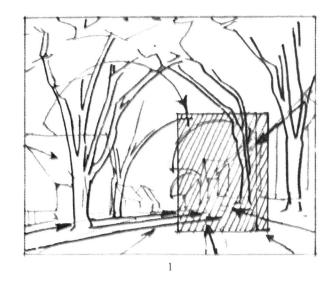

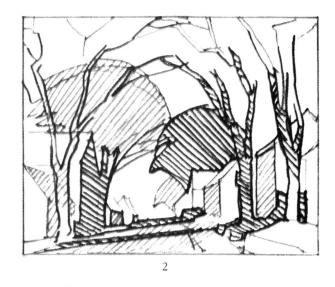

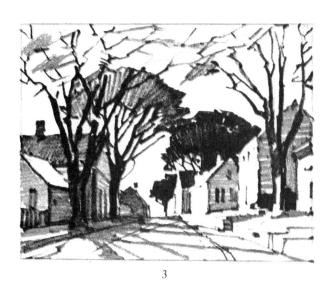

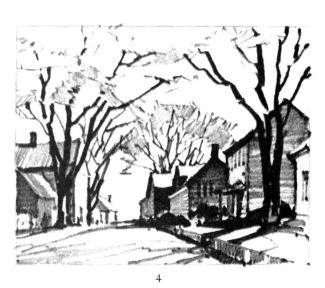

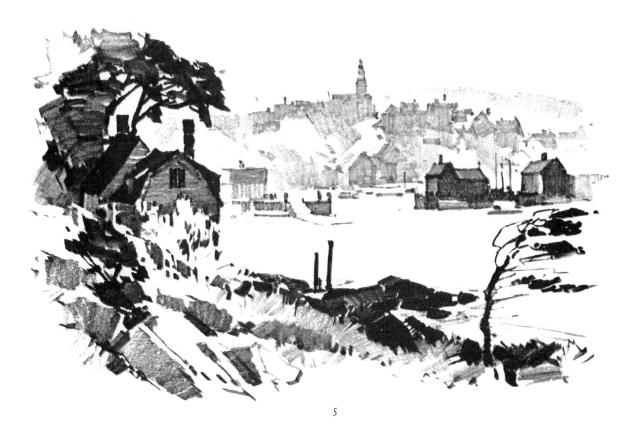

NEW ENGLAND VISTA

THE WINTER LANDSCAPE

The arrival of winter makes great changes in the landscape and intensifies the contrasts of black and white. It therefore furnishes admirable subjects for pencil pictures. Snow in sunshine is very white, while in shadow it offers every gradation of gray, in which reflected light plays an important part. The trees stand out sharply, both those which have shed their leaves and the evergreens, which seem to become even darker in winter. Buildings, too, share in the general play of reflected light across the landscape, and the shadows they cast on the snow model the contours of the ground with subtlety and exactitude. Let us go out to the country on a winter's day and see what we can find for picture material. We ahould not have too far to look. We can drive around in our car, if we come from the city, or we can don heavy boots and tramp along freshly plowed highways until we find what we want.

On one such day I came upon a gracefully steepled white church beside a crossroads and have made it the subject of our next plate. I chose a point of view where the church would be a little to the right of center. The low winter sun fell from the left, putting one side of the building in deep shadow and almost obscuring the minister's cottage alongside. A stone fence following the curves of the road threw its long shadow across the heaped-up snow and well into the roadway. Some naked trees in the field and beside the fence could be made to enframe the church and we had no scruples about shifting their positions a little to contribute to our design. Beyond the church were some dark forms of trees and other houses which could be used to throw the church into strong relief.

The line pattern analysis developed as in sketch 1, with the lines of the road leading in from several directions and the verticals of the trees holding the attention on the facade. The steeple itself formed a powerful accent to pin the eye down at the focussing spot. As for values, you will see in sketch 2 that the horizontal dark behind the church is used to furnish the background against which the building shines out almost spectacularly. The gray foreground shadows and the lighter ones across the field make the snow even brighter and are so

shaped as to help carry the eye to the center from every direction.

In rendering our final drawing, we follow the same principles that have been pointed out in other lessons. We develop our detail thoughtfully and sometimes playfully, thinking all the while of how each stroke will contribute to our design. In shadows the strokes can help to mould the forms of the rocks, the snowbanks, and the trees; while other strokes, crossing them, give direction and movement toward the focal center. We remember how things sometimes appear dark against light yet proceed to become light where they pass against dark. The degree of contrast rather than its nature gives them continuity.

In sketch 3, opposite, I have made a picture out of simple elements. A small, weathered barn, a few trees, a distant hill, and a snow-covered barnyard made an effective grouping, granted a little thought to make them build a design. The barn door, a little to the left of center, takes a deep shadow, intensified by the snow on the roof. The vertical trees, stark against the hill and the gray sky, lead down in strong contrast with the horizontal ground level. Notice that the trees are spaced rhythmically and not equally, so that they do not become monotonous. Some ruts, with light tree shadows across them give some diagonal relief to the foreground as well as performing the well-known function of leading the eye.

Another little farm group, made up of much the same sort of material but with accent on the diagonal movement and the S-curve rather than upon the vertical-horizontal contrast, appears in sketch 4. Almost any farmhouse has outbuildings in settings of woods and fields that will give you many a picturesque subject.

Below, in sketch 5, I have made another elliptical arrangement, with a barn and silo standing on a snowy knoll, encircled by the dark, distant background of forested hill and the profile of the foreground road from which we view it. This is the gray foreground, light middleground, dark background theme described in our analysis on page 6. You have no doubt been watching all the pictures thus far discussed to decide which classification they belonged to. It is well to do this.

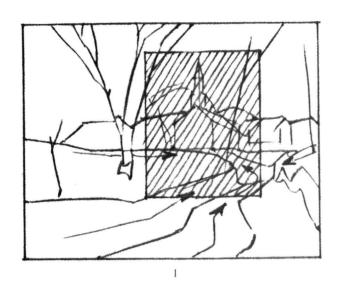

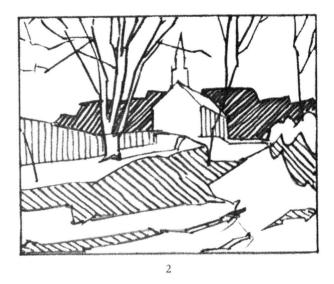

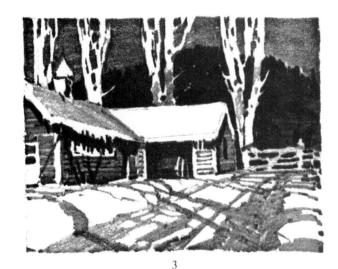

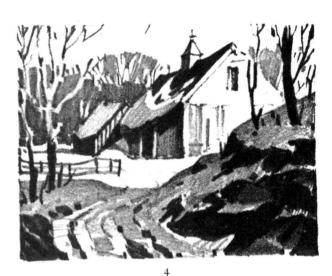

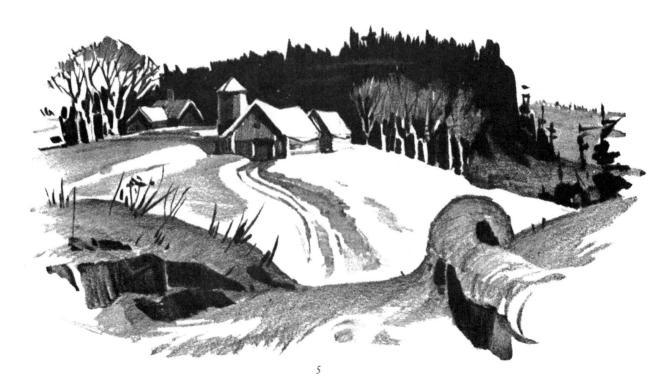

SNOWY CONTRASTS

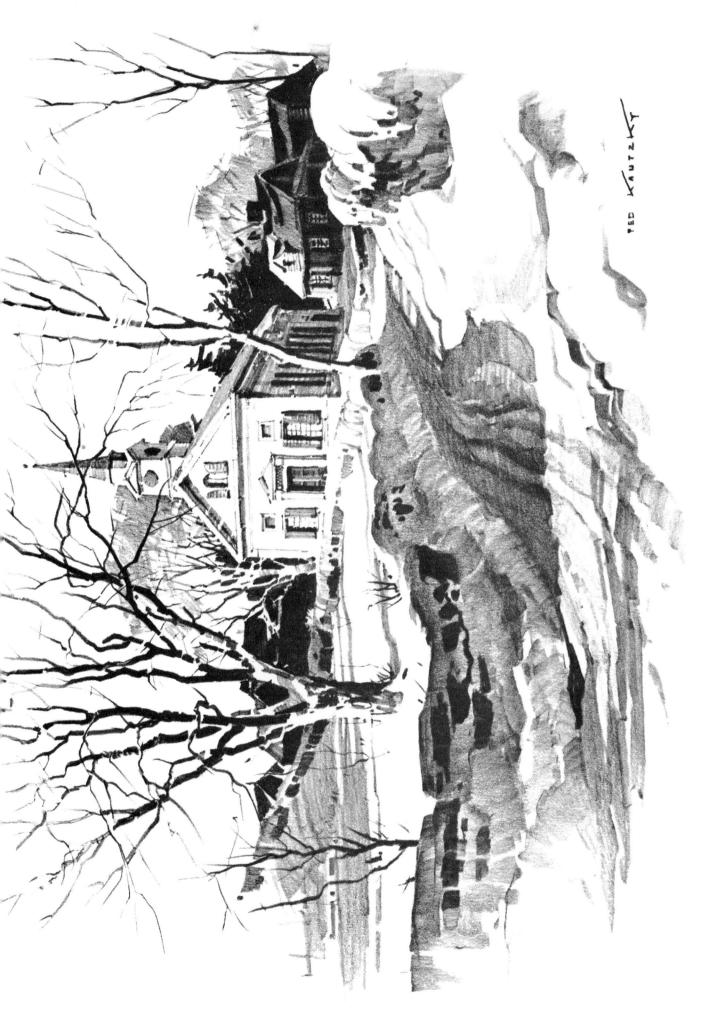

THE FARM GROUP

Farmhouses and their accessory buildings in every part of the country are somehow always picturesque. The barns, new and old, the chicken houses, the sheds for various purposes, the silos, the windmills, and all the multifarious buildings that farm life seems to demand are usually arranged so that they hold together and tell a story of the kind of life lived in and around them. Not only that, but they make a design of solid geometric shapes — prisms, cylinders, cones, etc. — with which the artist can construct an unlimited number of patterns when he puts their three dimensions on two-dimensional paper.

Let us take one such farmhouse as our subject for the next exercise in picture making. It happens to be in New England and is of the old gambrel salt-box variety with a big central chimney. Some ancestor of the present owner has thoughtfully planted a sycamore which has now grown into a stately, spreading tree rising high over the roof and giving welcome shade from the summer sun. This tree and the shadow of its branches on the gable end of the house will make an excellent center of interest for our picture.

We plan our rectangle with the principal focus to the left of center and sketch in our important eye-controlling lines as we find them in nearby objects. An old ramshackle shed at our left as we sit facing our subject will give us a set of lines vanishing downward toward the tree. The road curves first toward the house and then away from it, which fits into our plan, since it travels both ways. The limbs of the tree itself, silhouetting against dark masses of trees beyond, form a most powerful converging force from the top down. A series of horizontals — the path to the shed, the fence, the base of the house, the second fence, the roof lines of the buildings — afford us a succession of steps toward our objective.

We decide on a dark background formed by the wooded hill behind the house and partially merge this dark area with some foreground darks at the left, culminating in a pointed shadow on the ground which directs attention back at the house and tree. For the gray parts of the picture we use the middleground grass, the foliage of the tree, and the front and roofs of the buildings. This

leaves our foreground in bright sunshine, balancing the bright sky and increasing the tendency for the eye to come to rest midway between them, on the gable end of the house.

Partly to break up the sky area at the right and partly to stop any tendency for the eye to escape on that side, we ring in the old trick of putting in a slender tree, which serves also as a foil for our big tree. Incidentally, whenever there is just one big tree in the principal area of your picture, be sure not to put it right in the middle. This is true advice in general but is especially pertinent in the case of such a prominent downward-thrusting form as indicated in the diagram.

There is nothing much new to be said about rendering the final. Your arrangement is all set and you have but to apply the principles you have already learned. By now, this should be a habit. Again, I have made two little sketches of the same scene with different lighting. One has the sun coming from the right and our tree and gable are made dark against a gray distance. In the other, it is winter, and we have back-lighting, as the photographers call it. No matter which way we look at it, we have a picture!

In drawing closeup views of architectural detail, it is often well to choose to have the light falling across the most important surface at a sharp angle so that even small irregularities in the surface will show up and give character to the texture. In sketch 5, opposite, I have not tried to make a "picture," though I have tried to put balance and emphasis into even this segment of a picture. The thing I have tried to demonstrate is that by letting each clapboard shade the one below it and following the streamers of light and shadow across the surface in long diagonals we have a chance to make an infinitely more interesting job of it than we would if the sun were shining full from the front. The principle is the same as that followed in lighting scuplture in a museum, particularly when the modelling is delicate. When a subject so lighted is drawn skilfully it is full of life and sparkle, even though grays are predominant. Lighted from the front, it becomes flat and loses "color," even though the sunshine itself may be extremely brilliant.

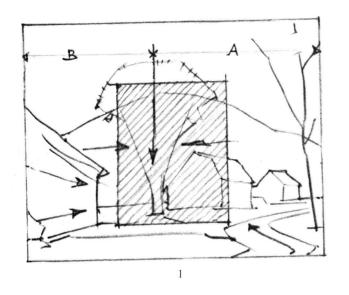

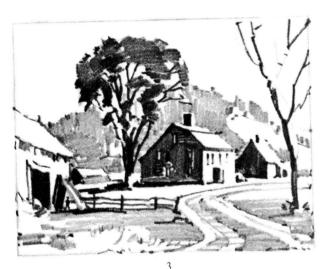

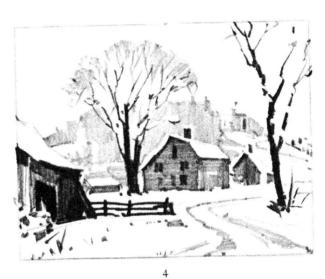

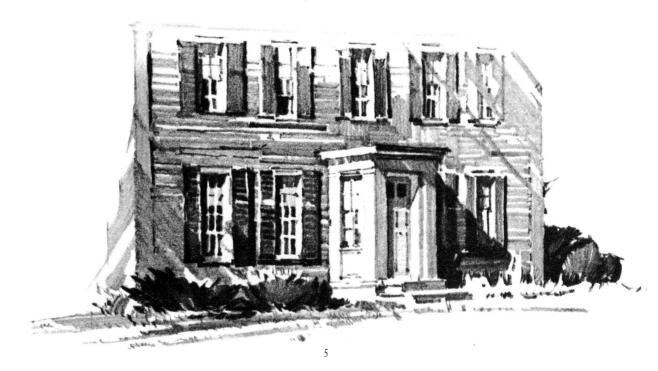

BALANCING FORMS—DETAILS

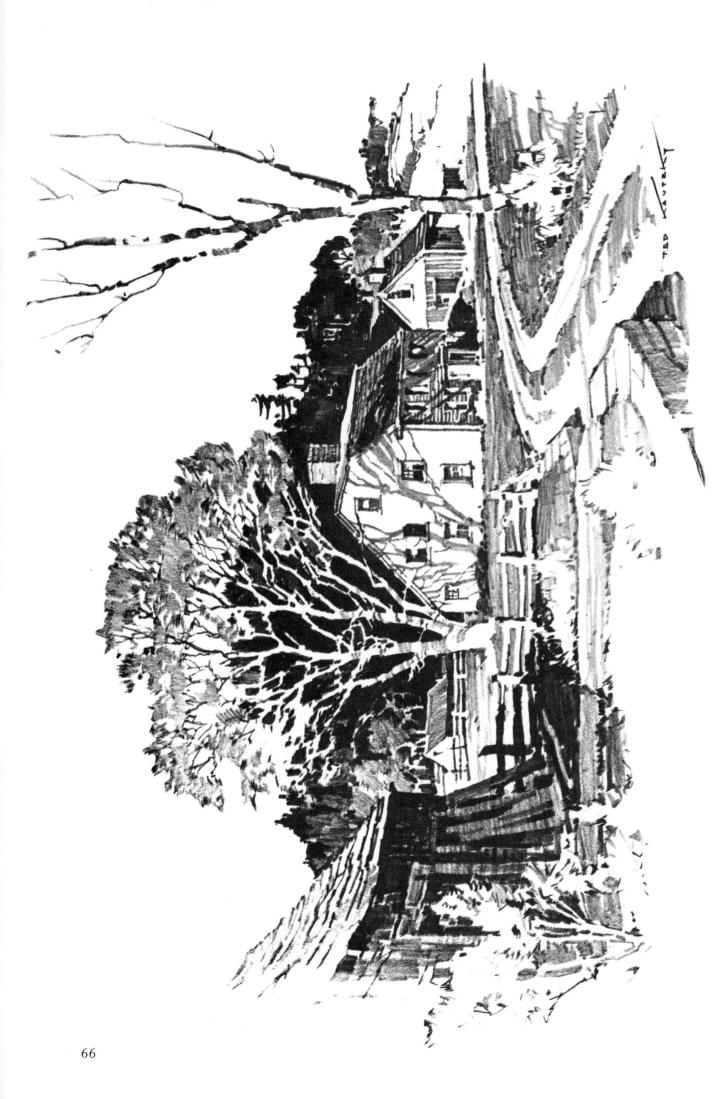

IN ROLLING COUNTRY

Most of the pictures we have been analyzing have been scenes in which the land itself has been secondary to other elements — trees, houses, barns, etc. Now let us go out to the hilly terrain and see what we can do with the curving profiles and contours of the rolling landscape as material out of which to weave our patterns. We will, of course, encounter houses and barns, and may even make them the focal points of our pictures, but they will be more incidental than heretofore.

First of all, we will be dealing with curved forms and lines rather than straight ones. Even the highways are winding in such country, as they follow the line of least resistance to hold to their grades. Our first try will be a view across country, looking from beside a twisting dirt road, across a field and past a group of farm buildings toward a series of hillsides arching one into another.

The principal line, as we see it, is an S-curve following a line of dark trees extending across our view from left to right, down a little slope to the road, then up on the other side and over a hilltop. Against this nearest hill, the farm with its barns and windbreaking trees stands out clearly to make an obvious center of interest. The curve of the road as it recedes from us hooks around and points to the buildings before it turns the other way and disappears down into the valley. Farther away, two successive hills give us additional inleading lines. The telephone poles, vanishing in perspective, form vertical barriers to escape for the eye at the left and set up a counter movement converging rhythmically toward the center.

The value scheme develops with the principal dark extending across the middle distance, an essentially light foreground broken up by a strip of stone fence, and a gray background for the distant hills at the left. Our farm group breaks into the dark hillside with its silhouette.

In our final drawing at full scale we have a wealth of opportunity to make every stroke do its share in leading attention to the barn and silo. Vertical strokes on the barn itself, reinforced by the punctuating forms of the cupola, silo, and flanking trees, nail our principal focus firmly in place against its level base. The curving hillsides, both dark and light, are modeled with long arcs that

converge unobtrusively but surely upon our objective. The jagged and expressive silhouette of the dark evergreens not only describes the nature of the windblown trees but adds its strong downward thrust as it throws its long encircling arm around the central area. In the foreground we insert a gate of chestnut rails into our stone wall at such a place that its diagonal leads right into the picture. Study this plate and you will see many more ways in which the eye is compelled to go where it is wanted.

As before, I have demonstrated that the same subject can make a picture with the values entirely rearranged. Sketch 3 depends on a clean dark silhouette of the barn and silo against the hill, which is now made light. The sun is coming from the right and towards us and the light immediate foreground merges into the gray middleground which extends away from us and terminates in a sharp horizontal at the base of the buildings. At 4, we have a poetic twilight mood, with the dark foreground grading away into the distant light in a sequence of silhouetting planes. In all of these arrangements the curves are the predominant elements of line movement.

At the bottom of the page, I have taken the same barn and silo, turned around a little, and made a close-up picture with the gable end as the principal item of interest, very slightly to the right of center. The inverted "V" of the roof line is complemented and echoed by the flat "V" of the ground line as it dips to the basement entrance. The light is at our back and to the left, which gives us a strong shadow on the side of the barn. This is balanced by the mass of dark foliage at the left. The cupola and silo are allowed to silhouette clearly and their forms add interest to the skyline. Together with the tall poplar, they pin down the right side of the picture and keep the eye from wandering out.

See if you can take this same subject and by reversing the direction of light and changing the value arrangement make another picture with a different mood. Then experiment some more with subjects of your own choosing. You are certainly by now getting the hang of it and acquiring real control over what you draw. Is it not so?

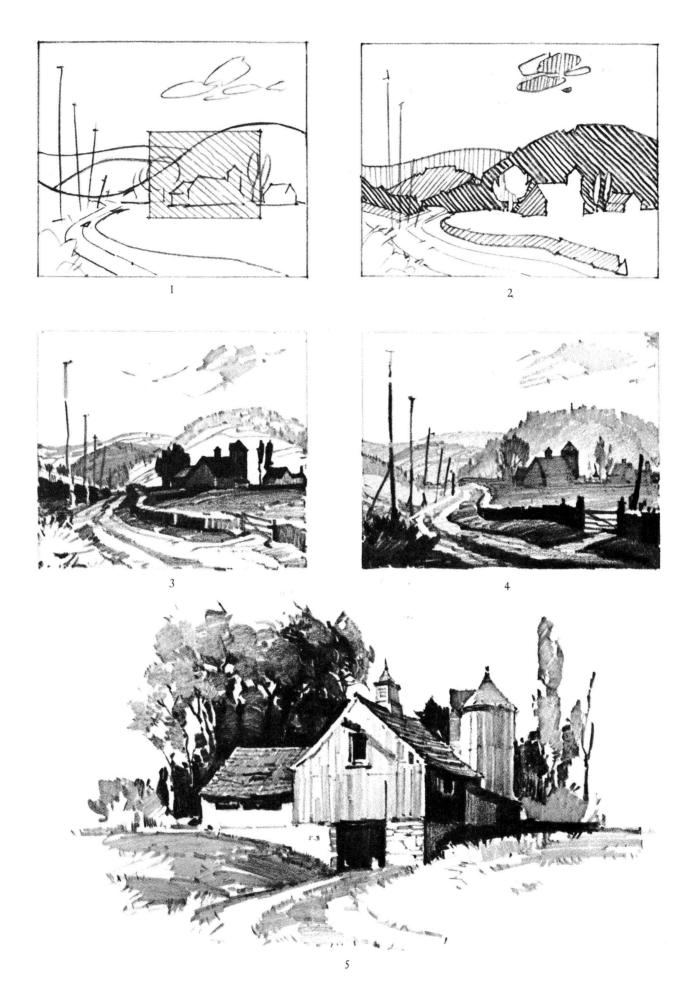

CURVING PATTERNS

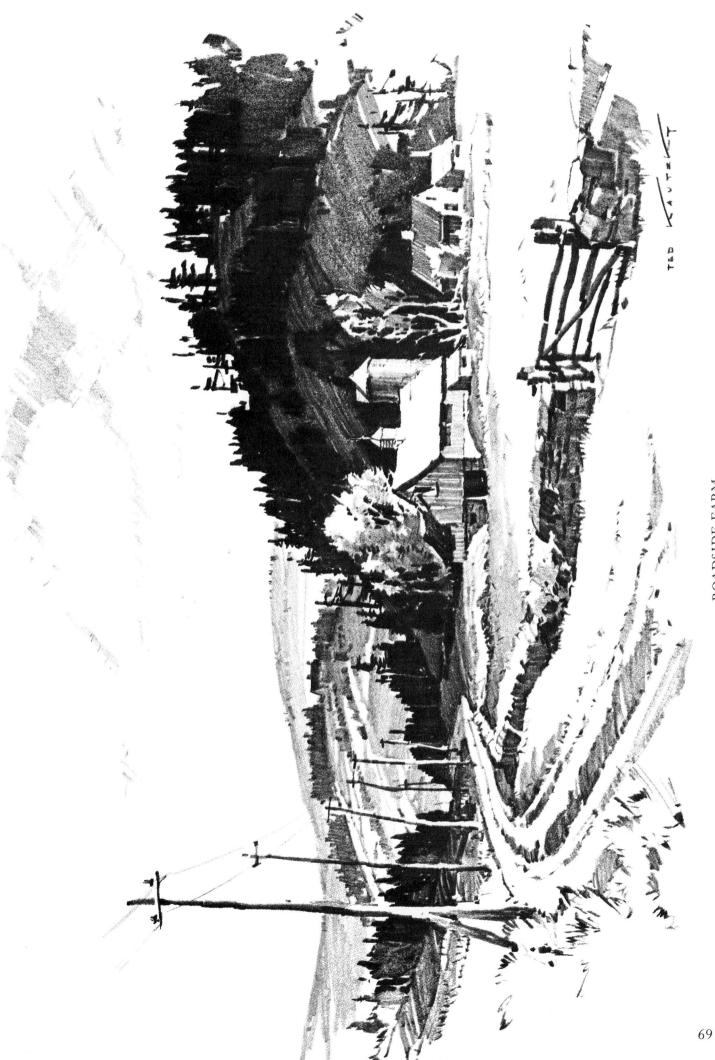

THE HILL FARM

In the highlands, up among the green hills, one frequently comes across a farmhouse that makes good picture material. The rectilinear forms of the house itself are in contrast to and complemented by the rounded slopes of the wooded hillsides among which it nestles. There is also plenty of chance for dramatic lighting effects, which continually change in such country with changes of season and weather.

A friend of mine had such a farmhouse in Vermont and I decided to use it for the accompanying lesson plates. The long, low, horizontal lines of the house, extending back at right angles to the road, were set against a background of receding hills. The graceful, two-story, front portion presented its gable end to the approaching visitor, and this, flanked by a comfortable, shaded porch in the ell, made a suitable center of interest. Choosing a low horizon level, so as to include the hills in our picture, we developed our line diagram as at 1, with the focus a bit to the left.

The road, as it passed the house, was actually straight, but we took the liberty of curving it a little to keep its strong perspective influence from leading the eye out to the left. The sloping profiles of the hills lent themselves easily to our scheme by leading down on both sides of the road toward the house. Since they were much stronger on the right, however, I felt the need for an extra force at the left of our gable and so I moved a venerable maple across the road to a position where its arching limbs effectively enframed our focus and held our gaze in position. To add foreground interest, as well as to provide more leading lines, I imagined a bit of rail fence, a rock, and some roadside weeds, all of which helped to direct and hold attention where I wanted it. To keep the long sloping line of the hill from leading out to the right, I arranged some cloud forms in opposition. A few trees back of the woodshed end of the house could effectively stop the outward movement of the long horizontals.

Values were arranged to give a strong silhouette to the house, with its interesting roofline and picturesque chimneys, by making the more distant hill dark and including some dark foliage just back of the ridge line. Grays were distributed to balance around the center, with large areas on the nearer hill and the big tree and smaller ones for the shingled roofs, grass, cloud shadows, and foreground objects. The strongest light, as well as the strongest contrast, was reserved for the gable end. This planning gave us diagram 2.

The final picture developed as shown in the full page plate overleaf. You will observe that in this drawing I have used all the devices we have discussed earlier. The calculated direction of strokes, the play of light against dark and dark against light, the clean edging of silhouettes to define form and attract attention, the soft edges in outlying portions, the practice of leaving little flecks of light in gray areas to suggest sunshine — all these and more are tricks of drafstmanship that are based on truths and that help to give reality. But the really important thing is not the technique but the arrangement which makes our drawing a picture. That is what you are trying to master and what will make you an artist if you master it. Just to show you that one arrangement does not exhaust all the possibilities of our material, I have made three other pictures of the same scene. At 3, we have the house and foreground lighted up momentarily by sunshine from the right while a storm is gathering in the distance. At 4, is a peaceful twilight effect with the afterglow lingering beyond the hills. At 5, drawn at a different scale, is a winter scene, with a light snow covering the fields and roofs and hilltops. You can, if you try, conceive of others.

The material for this sketch and its variations was derived from one photographic print, sent to me by my friend. Naturally, the photograph is not like any of the finished sketches, for the camera must include everything within view just as it is and cannot move things around and change the emphasis. That is why the camera picture, however skilfully taken, can never quite rise to the heights of excellence that can be achieved by a real artist. The camera is sometimes a real aid to the artist, for it enables him to make quick records of material he might not have time to sketch or to have access to places he cannot visit. It should be used sparingly, however, and wisely, with firm resistance to any temptation to copy blindly.

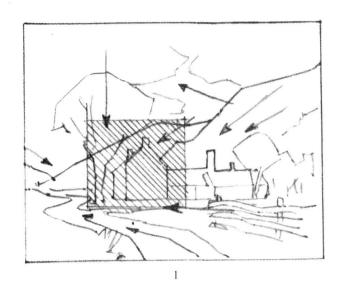

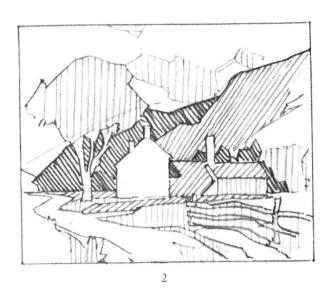

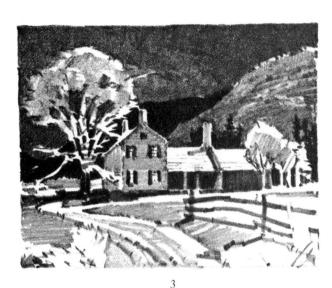

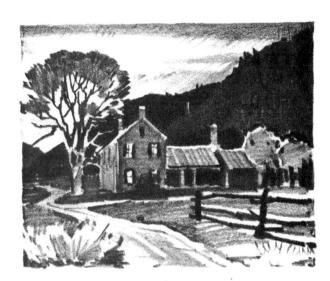

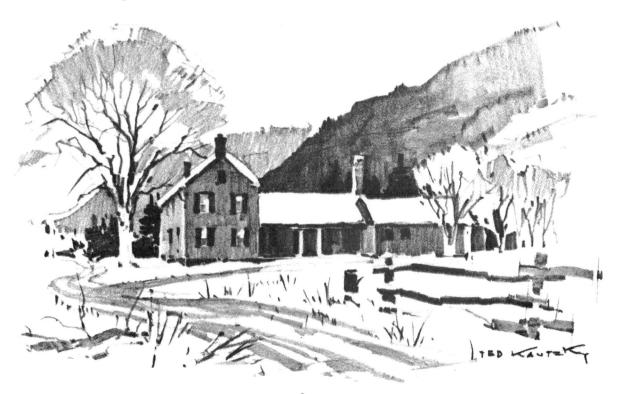

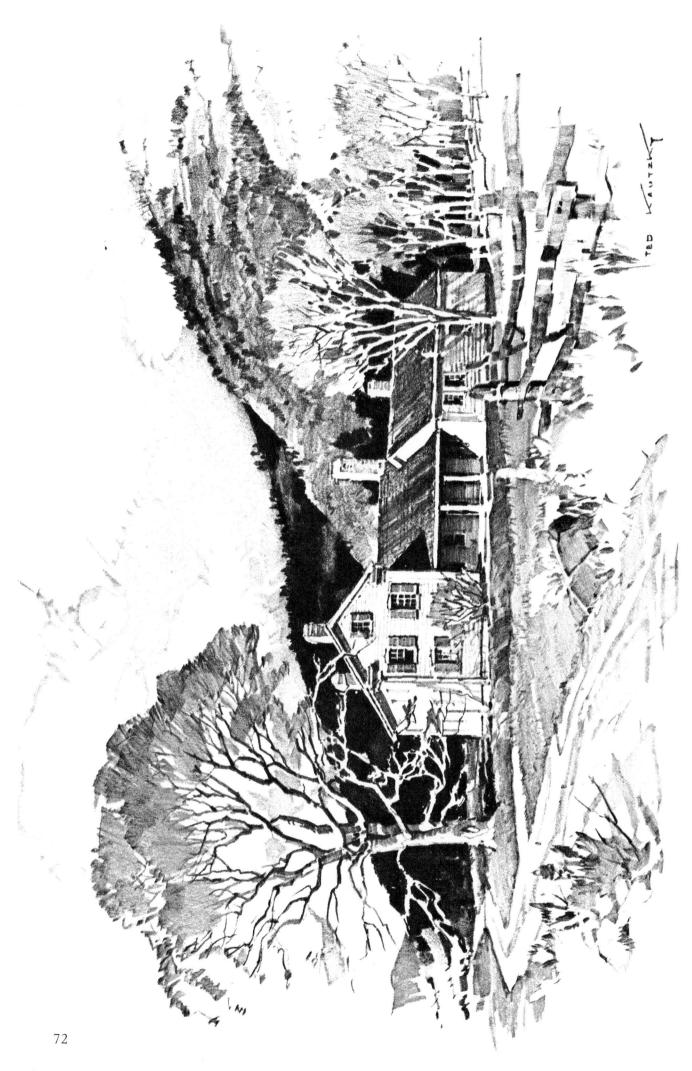

IN THE FOREST

There are people who are said to be unable to see the woods for the trees, and others who conversely are unable to see the trees for the forest. The artist must be able to see both. He must know individual tree forms and must also know how the trees live together in nature and affect each other's habits of growth. It is one thing to draw a single tree, of definite species, so that its characteristics are unmistakably expressed. It is another to draw a group of trees, a grove, a forest, so that it will be convincingly real.

As an exercise in making a picture out of a bit of woodland, we will take up our position in a little birch grove, in winter, where we can look out through an opening, across a frozen, snowcovered pond, toward a spruce woods beyond. This will give us a chance to draw individual trees, small groups, and massed growth.

By the very nature of things, the general movement must be vertical, following the lines of the trunks, with the horizontals of the ground furnishing the contrasting opposition. We can arrange for some diagonals, too, in the shape of branches, and can even have a tree or two falling over where it may suit our convenience. A lot of straight trunks, closely and equally spaced, would be deadly monotonous, to say nothing of their lack of reality. What we find is that the trees in a wood are unevenly spaced, of varying thickness of trunk, and of different degrees of dark or light textures. Within reason, we can play upon these divergencies and create interesting rhythms.

In the present instance we are standing close among the nearer trees, so we cannot include their tops in our rectangular frame. We make the most of this situation by deciding to group their slender trunks in an irregular and interesting rhythm. We choose to make what we see through the little opening our center of interest, and place it a little to the right of center. We group the trees on either side in three clusters, two at the left and one on the right. The clusters are all different in the number, size, and spacing of the trees they include. A slim, triple-stemmed birch at the edge of the pond is placed in the center of interest to give the eye an anchoring post. Our line diagram now needs some horizontals which are conveniently supplied by

the long shadows on the ground and by the massed trees along the far side of the pond. To break the monotony we introduce a leaning tree at the left, which helps also to force the eye into our center.

In distributing our values we put a strong dark at the center of interest, where it will throw the little birch trunks into relief. We then make some of our nearby trunks dark, some gray, and some light — using whatever artistic instinct we have to produce a pleasing balance. The rest of the distant trees and our ground shadows are gray.

We draw our tree trunks in lightly and then proceed to render them with clean strokes; mostly short, curving horizontals to express the texture of the bark and give vibration. Occasional long vertical strokes help to model their roundness. The interlacing branches are put in with long, firm strokes that vary in thickness and direction following the growth habits of the trees as we have observed them. Where the lighter trunks and branches of the nearer trees pass along or across the darker ones behind them, they are clearly silhouetted and help to break up the darks interestingly. Character is given to the band of distant trees by simply taking care to make the jagged silhouette of their tops describe their nature. Finally, our ground shadows are put in with soft, undulating strokes of fluctuating widths accomplished by rocking our pencil. We are careful to add to the receding effect by spacing these shadows closer as they get farther away from us. I have provided several other sketches of woodland scenes in which you will discern the same principles. At 3, I have emphasized the importance of clean, suggestive silhouette by describing my subject entirely by this means. You can tell at a glance that the forest is of wind-beaten evergreens and that the creature in the foreground is a moose wading into the water to drink.

In the picture at 5, I have drawn two old dead trunks standing out starkly against the pines of the forest's edge. I chose these two trees for my central topic rather than three because it never seems quite satisfactory to put three similar objects prominently in a group. One or two or four or five make a pleasing unit — never three.

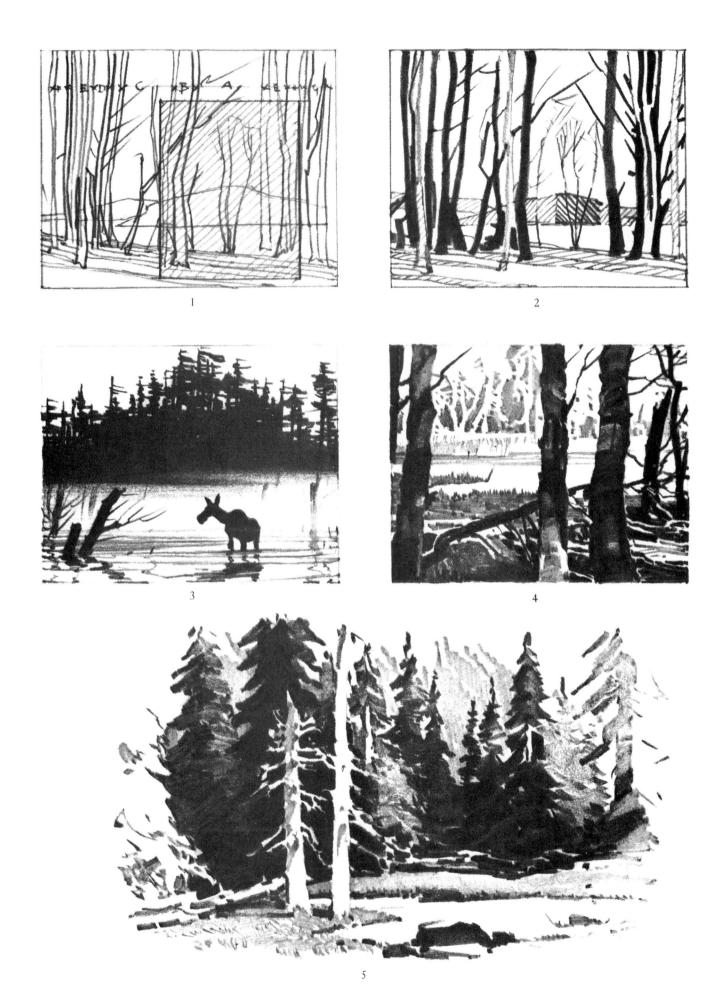

WOODLAND SILHOUETTES

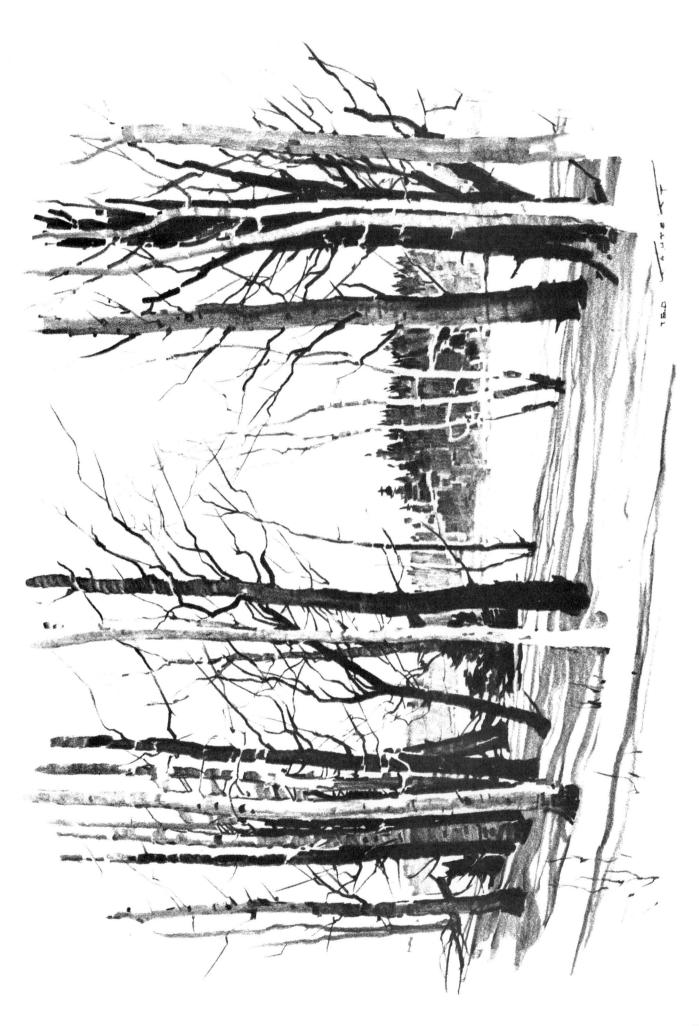

MOUNTAIN SCENERY

When we travel about in more ruggedly mountainous country, we often encounter striking scenes that prompt us to reach for pencil and paper. The bold and striking natural forms we see are of noble and majestic proportions and require greater scope for our canvas, so to speak, than the more intimate views we have been dealing with. How shall we ever put these huge vistas onto a 9" x 12" sheet? Well, it can be done by following exactly the same principles of arrangement as with smaller subjects.

As a case in point, I have taken for the following plate a mountain view that includes a little farm nestled close to a couple of steep and jagged cliffs. What was once the rounded shoulder of a small mountain, now looms up romantically against the sky, its naked rocks washed clear of soil by the action of centuries of wind and water. Out of its mass, nature has chiseled a series of stony towers whose architectonic forms suggest some medieval fortress. Here is a subject that has grandeur enough for broad treatment.

The castellated ridge terminates dramatically in a perpendicular wall of imposing height. We choose to make this our center of interest and to accentuate it we assume the sun striking in from the right. We place the sheer edge somewhat to the right in our rectangle and develop a series of strong lines leading to it - an approaching road, the profiles of the shadowed trees, the roof slopes and chimneys of the house, and the forms of the mountains lend themselves to our purpose. In sketch 2, we arrange our values to highlight the cliffside and surround it with darks and grays which funnel the gaze to the exact spot of our intended emphasis. The deepest black is placed close against the gleaming triangle or rock which is to form our focus and is balanced by another but smaller intense dark in the foreground trees. Grays are also distributed so that they balance around the central motif.

Rendering the final drawing is a matter of filling in the areas we have laid out with strokes of appropriate weight and direction. We model the forms, leaving patches of white paper in the lighter grays and putting rich blacks inside the shadows to define the deep fissures and crevices where the sun cannot reach. The mass of trees reaching up the mountainside is broken up with many short curving strokes that suggest the rounded crowns, with jiggly strokes here and there to give vibration to some of the leafy silhouettes. The skyline is given especially careful attention to make the crenellations count interestingly in broken rhythm. A few wind-battered pines along the crest give added character.

As you will have seen by now, the change in scale was not so difficult after all. It is just a matter of relativity. Things that required many strokes before have now become mere details in the broader picture, to be described adequately with a few well-placed strokes. The thing that counts is still the pattern we weave with lines and values.

A couple of other arrangements of the same material are shown at 3 and 4. Attention has been directed differently in each. Analyze them and strengthen your comprehension of picture-making.

At 5, I have depicted a long vista through mountainous forms skirting a valley through which flows a broad river. The elements are big but they are simply expressed with a few value areas. In rendering it, the foreground was made more lively and sparkling, as befitted its nearness. The serenity of the distance was expressed by merging its details into soft grays as they receded from us. See if you can follow the line scheme as it makes use of directional lines, vanishing parallels, S-curves, and lines in opposition. Then try to make some broad views of your own.

We have come a long way, have we not, since we started out on our long excursion into the realm of picture building. I hope that you have learned something as we went along, and that you have absorbed the principles that I have tried to express both graphically and in words. The most important thing is that you have presumably worked at it, making drawing after drawing and conscientiously analyzing not only the examples shown here but your own efforts and the work of others. If you have done this consistently over a period of time, you should have progressed at least a little way beyond the threshold of the gate to the world of creative art.

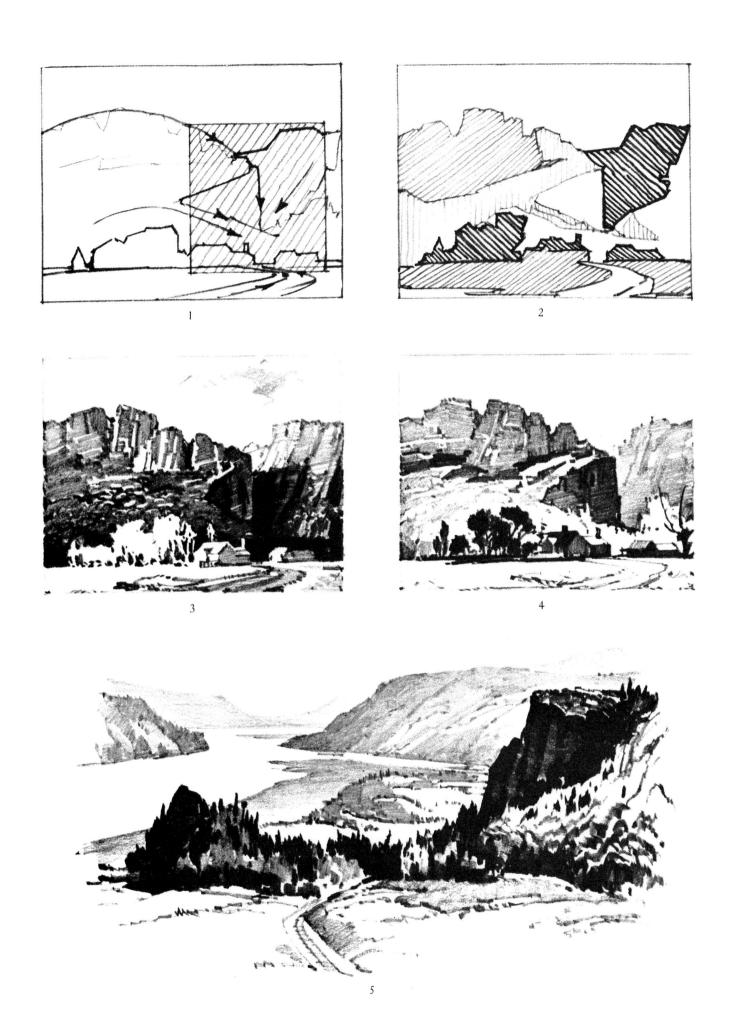

RUGGED FORMS

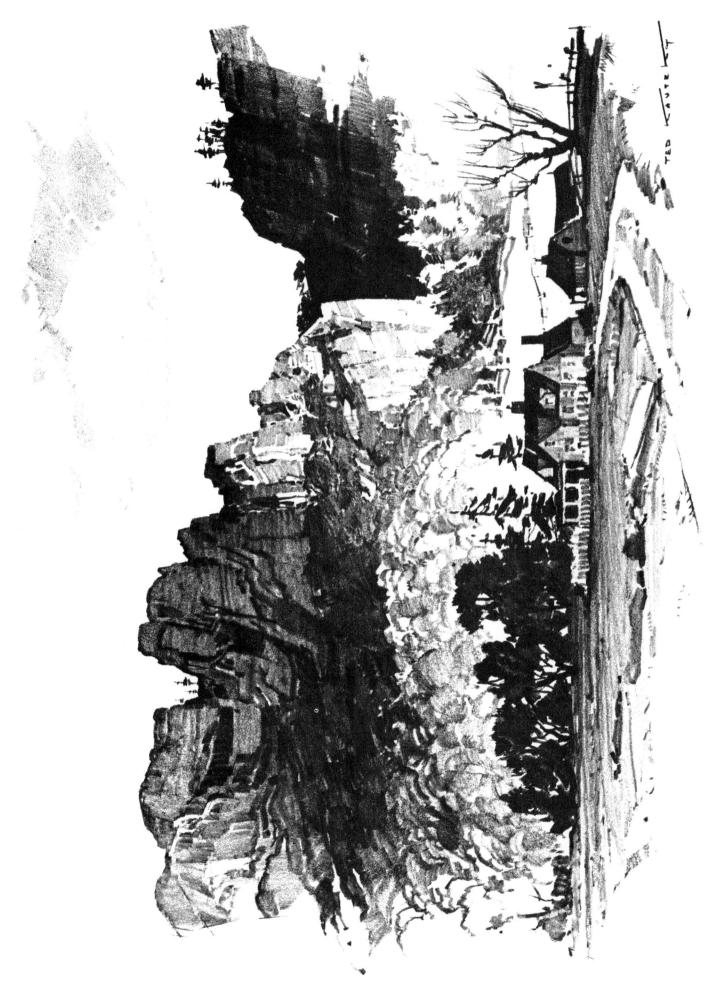

THE LOFTY PEAKS

We have now come to the final lesson in this book and since we started out at sea level, so to speak, it is perhaps appropriate that we should end up among the snow-capped peaks above the timber line. At any rate, I have chosen for our last subject a view in the western mountains, where the scenery is noted for breath-taking magnificence.

High up among the infrequently trodden snows, at the last level where substantial vegetation can exist, we stand at the edge of a little lake and look across to where a group of tall firs stands out against a snow-filled ravine on the slope of a conical peak. The mass of the treees roughly echoes the shape of the rocky crest above them, so we have here the opportunity to play up a contrast somewhat akin to that furnished by the gulls and the sail down by the seacoast. We decide to make the trees our center of interest, with a secondary center up the mountain top. Our tree group centers low down in the rectangle and a trifle to the right of the axis, with the apex of the cone a little farther out in the same direction. A flat, receding S-curve follows around the edge of the pond and returns toward our focus along the base of another group of trees. The angular forms of the mountain press down from above and some foreground rocks at the water's edge are made to slope their planes in the right direction. To increase the sense of depth in our picture as well as to provide a barrier against escape at the left, we put in the trunk and lower branches of a full-grown fir tree which gives a strong contrasting vertical. Its shaggy branches are also useful in directing attention down and in from the left.

Our value diagram shapes up easily as at 2, with the strongest dark of the trees against the bright snow beyond. Other dark trees and bits of ledge showing through near the peak are made to contrast more softly with the gray shadows around them. The dark reflections in the water accent the position of the trees which cast them and also intensify the importance of the farther shoreline.

When our scheme satisfies our sense of balance, we go ahead with our drawing at full size. Clean detail and accuracy of definition of forms and areas now become important, and we display our

hard-won knowledge of how to render textures. The trees are handled almost in pure silhouette, for their profiles are sufficiently descriptive and we want them to stand out boldly. The placid water is best expressed by vertical strokes for the reflections. Through them we cut a slender horizontal streak of light where a puff of air has passed and caused a slight ripple to reflect the sky. Note that by making this strip of light nearer the far shore rather than halfway, measured up and down on the vertical plane of our picture, we increase the illusion of depth. The trunk of the foreground tree is rendered with a combination of short horizontal curving strokes to mould the form and some long vertical strokes to express the texture of the bark. Smooth shadows on the snow are put in with broad even strokes, close together and ending cleanly at the sun line. Where the snow has melted or blown away from the rock formations, I have found it well to use short strokes going across the shorter dimension of each exposed patch. This is somehow more expressive of the texture. So much for the technical points.

The smaller sketches opposite are, or should be, more or less self-explanatory at this stage of your progress. I will leave it to you to interpret them to yourself, for I have a few final remarks to make and just enough room to make them.

I have earnestly tried in this book to give you helpful guidance. I have explained, as clearly as I knew how to do so, what the artist's mental processes are as he plans his pictures and executes them. I hope that I have impressed upon you the fundamental ways of analyzing your material, selecting what you need, and putting it together in such a manner as will produce pleasing results. I have not tried to make you overnight into a finished artist. That is something that takes years of work and presupposes a natural talent that you may or may not have. I do believe, however, that you should have derived from these pages a better understanding of pictures and their making than you had before you began to read and draw. If I have accomplished this much, my time and yours has not been wasted. I wish you the best of success in both making and appreciating better and better pictures — Pencil Pictures, let's say!

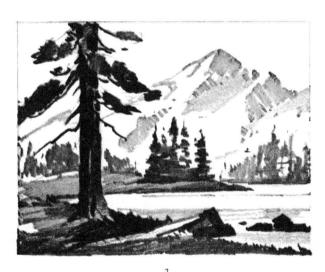

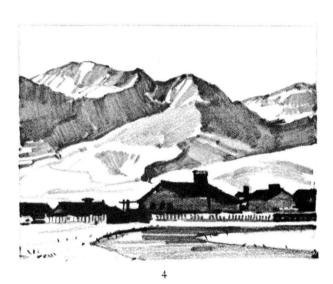

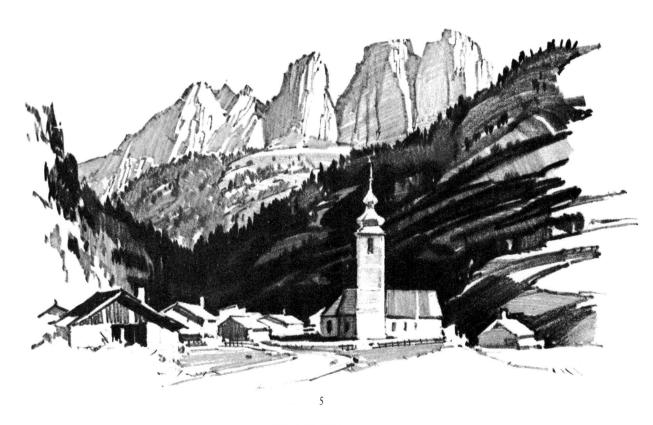

APLINE HEIGHTS

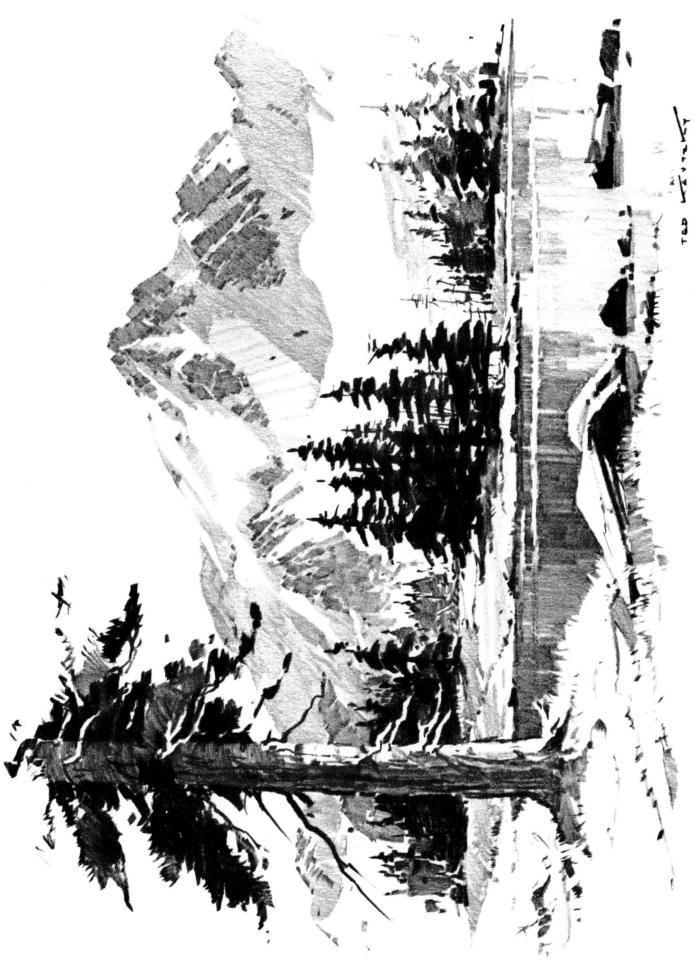

PORTFOLIO	OF	BROAI	D ST	ROKE	DRA	WINGS

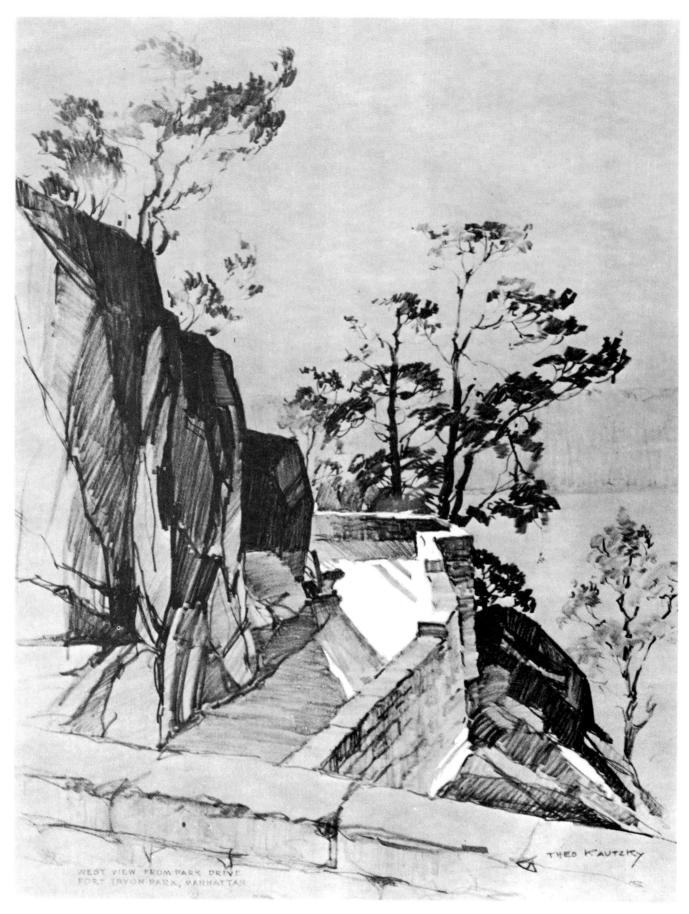

FORT TRYON PARK, NEW YORK

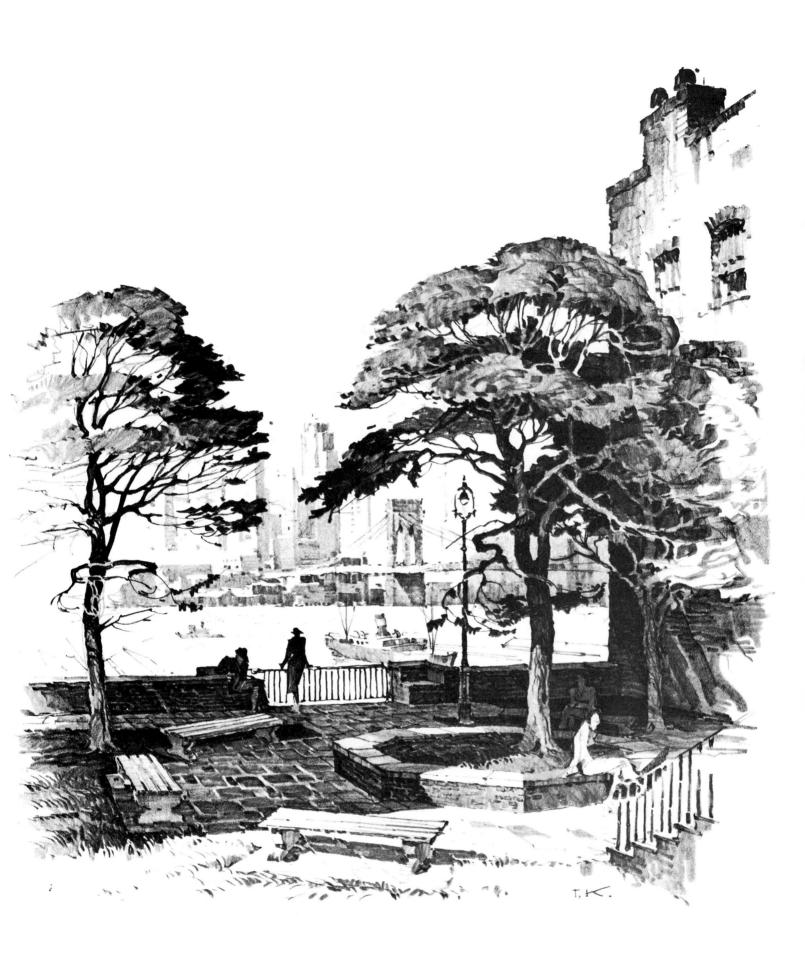

BREATHING SPACES FOR NEW YORK

One of a series of drawings made for the New York Department of Parks and originally published in Pencil Points Magazine.

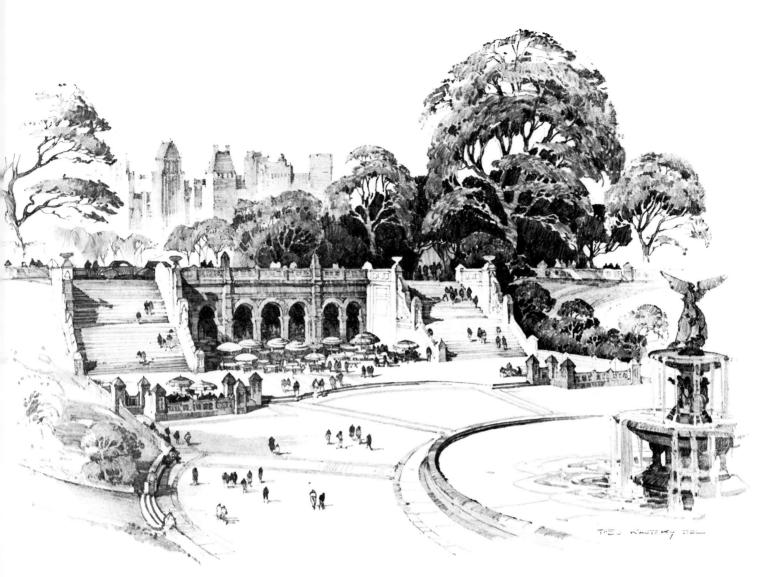

CENTRAL PARK, NORTHERLY TERMINUS

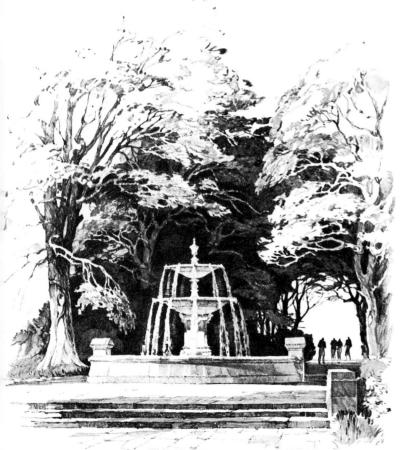

JACOB SCHIFF MEMORIAL FOUNTAIN, SEWARD PARK

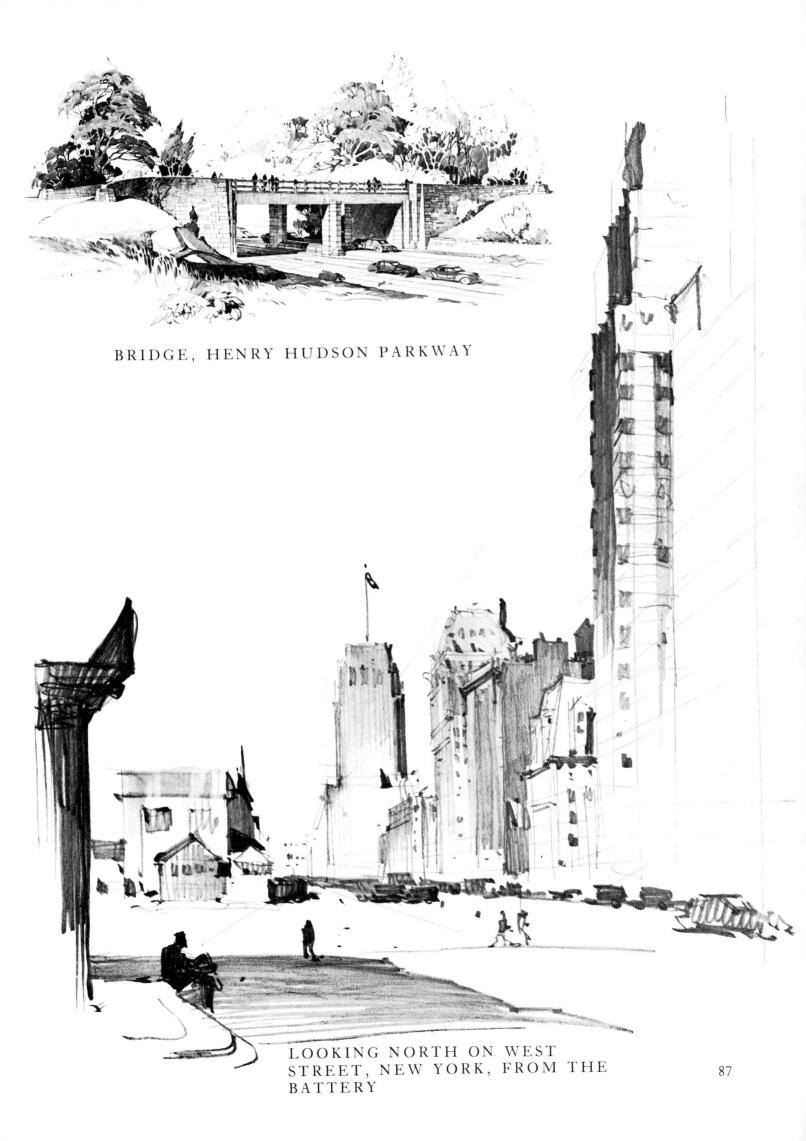

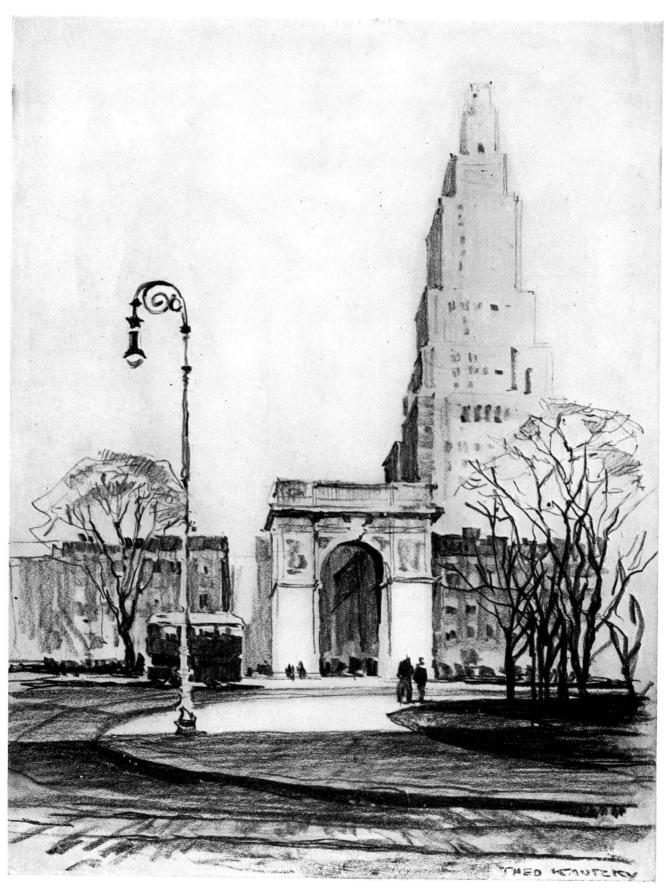

PRELIMINARY SKETCH MADE IN WASHINGTON SQUARE, NEW YORK

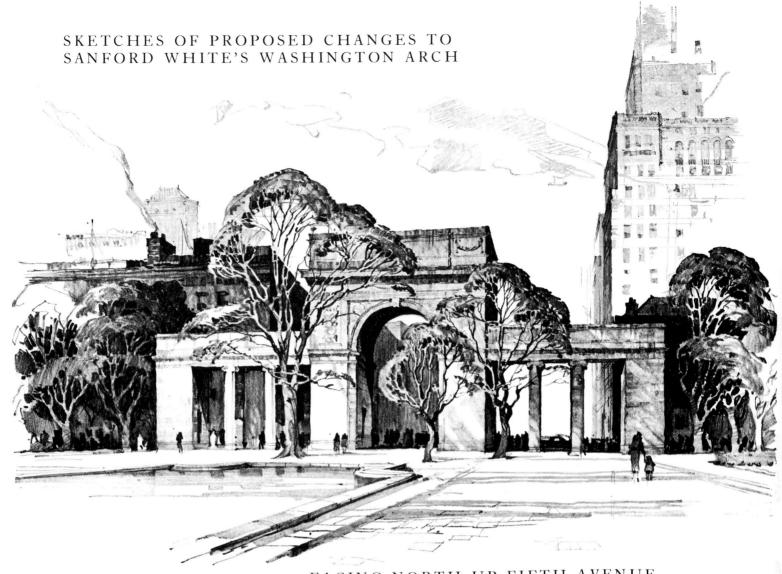

FACING NORTH UP FIFTH AVENUE

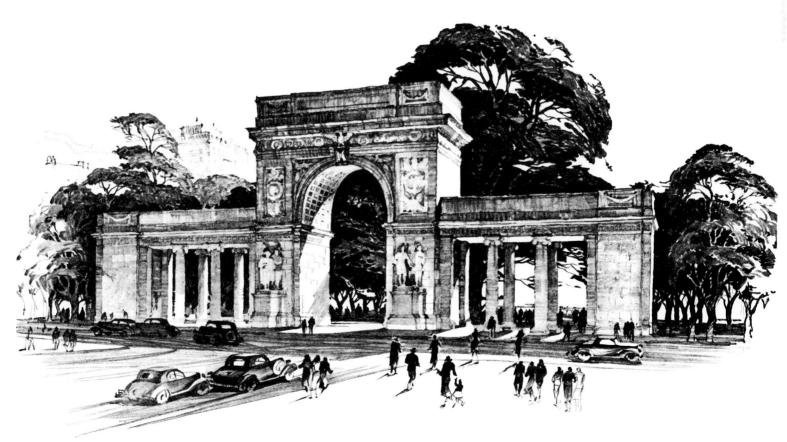

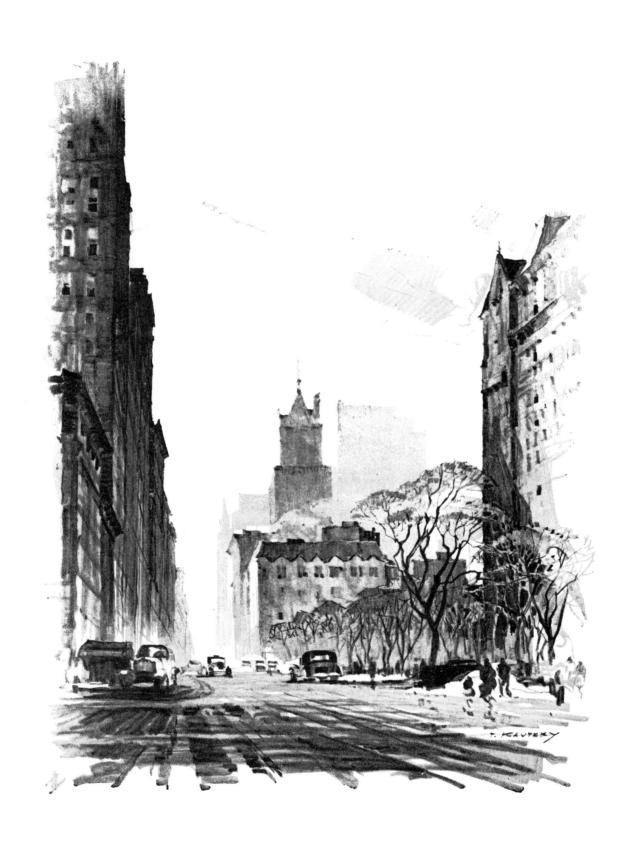

FIFTH AVENUE, LOOKING SOUTH FROM ABOUT 59TH STREET

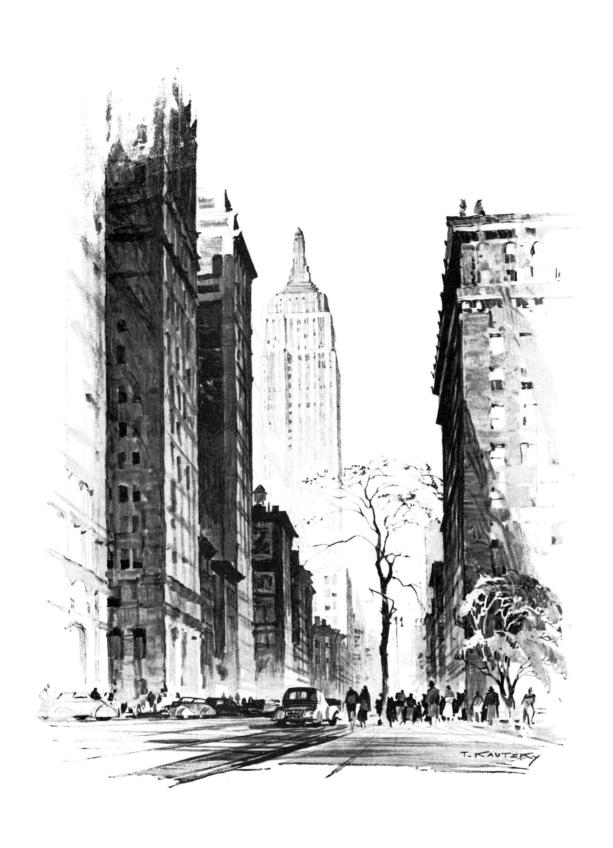

FIFTH AVENUE, NEW YORK, LOOKING NORTH FROM MADISON AVENUE

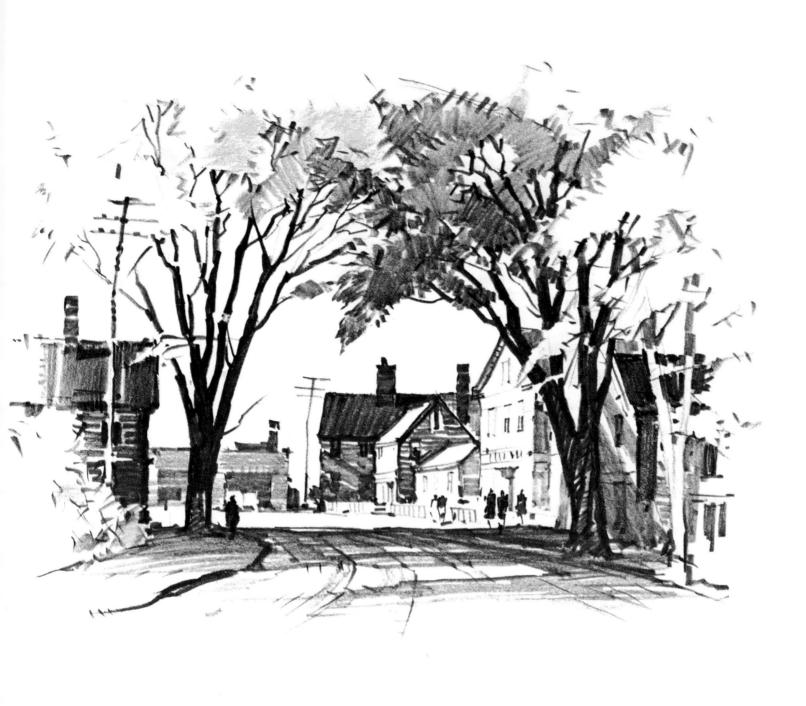

STREET, ROCKPORT, MASSACHUSETTS

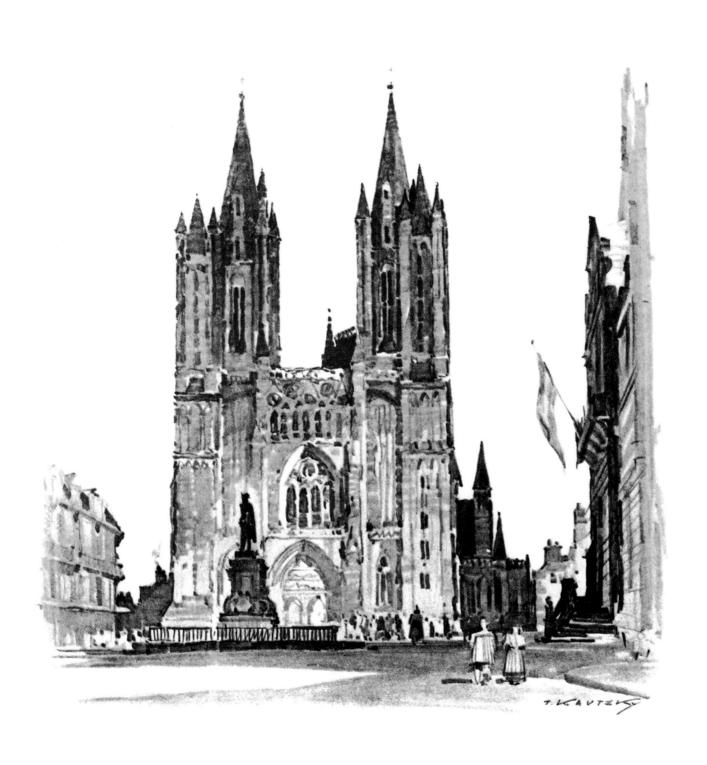

CATHEDRAL, COUTANCES, NORMANDY

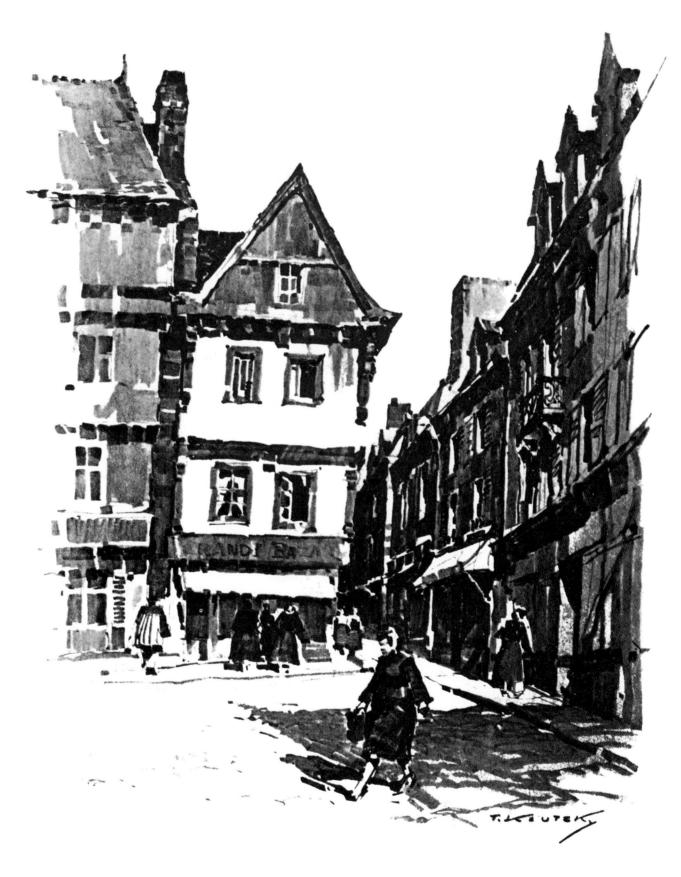

STREET, LANNION, BRITTANY

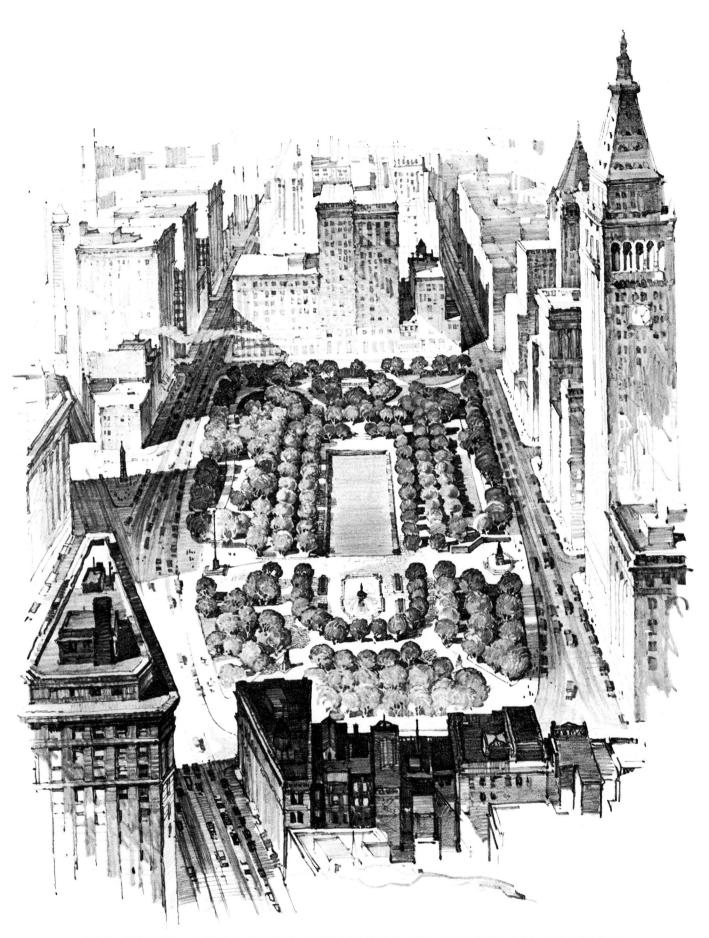

AIR VIEW, PROPOSED CHANGES IN MADISON SQUARE

RENDERING OF A SMALL HOUSE

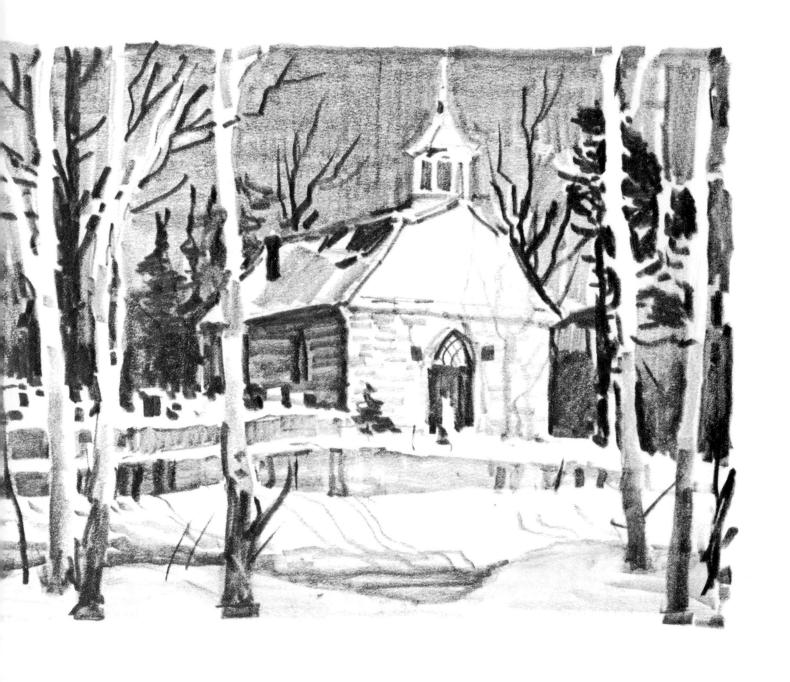

CHURCH, IRVINGTON-ON-HUDSON, NEW YORK

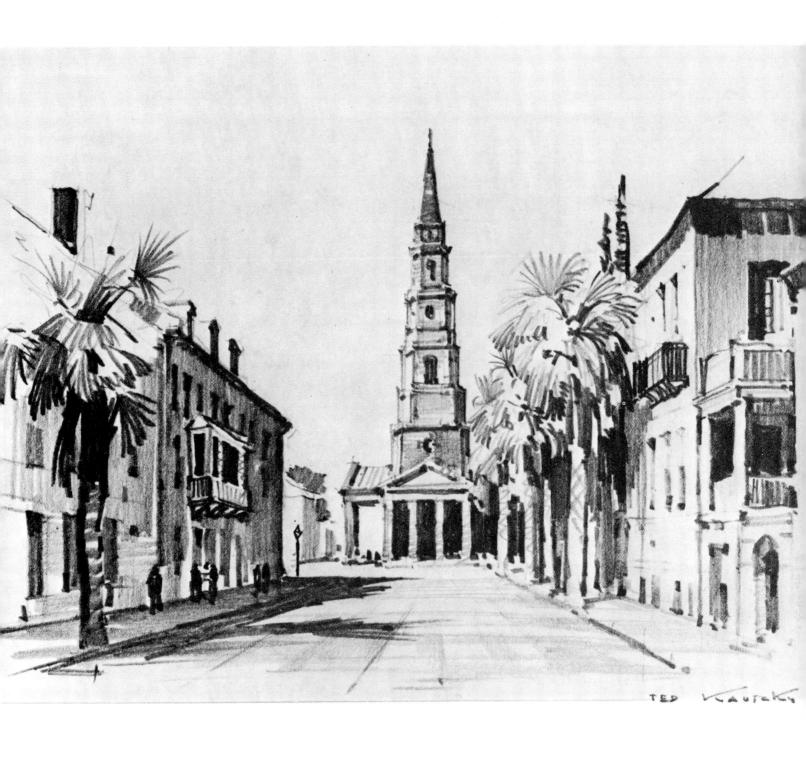

STREET, CHARLESTON, SOUTH CAROLINA

CHURCH, NORTH CAROLINA

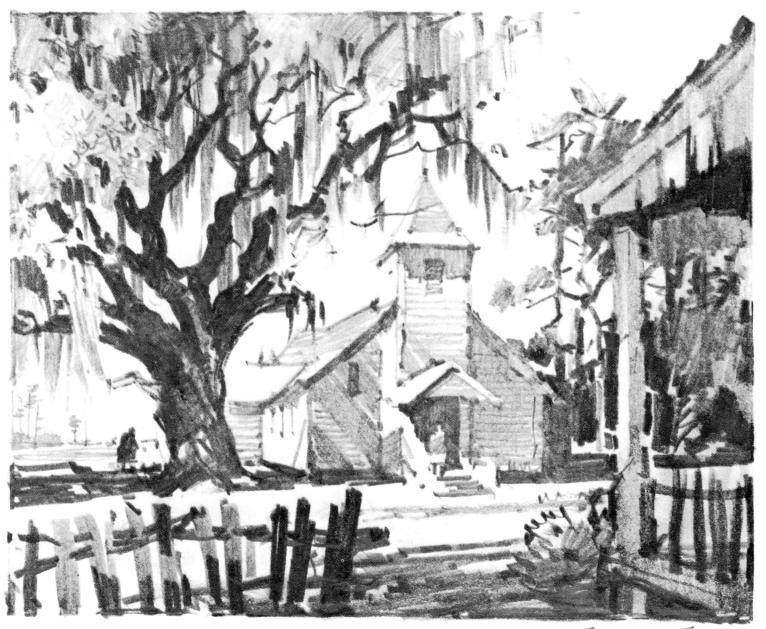

PED KAVTZKE

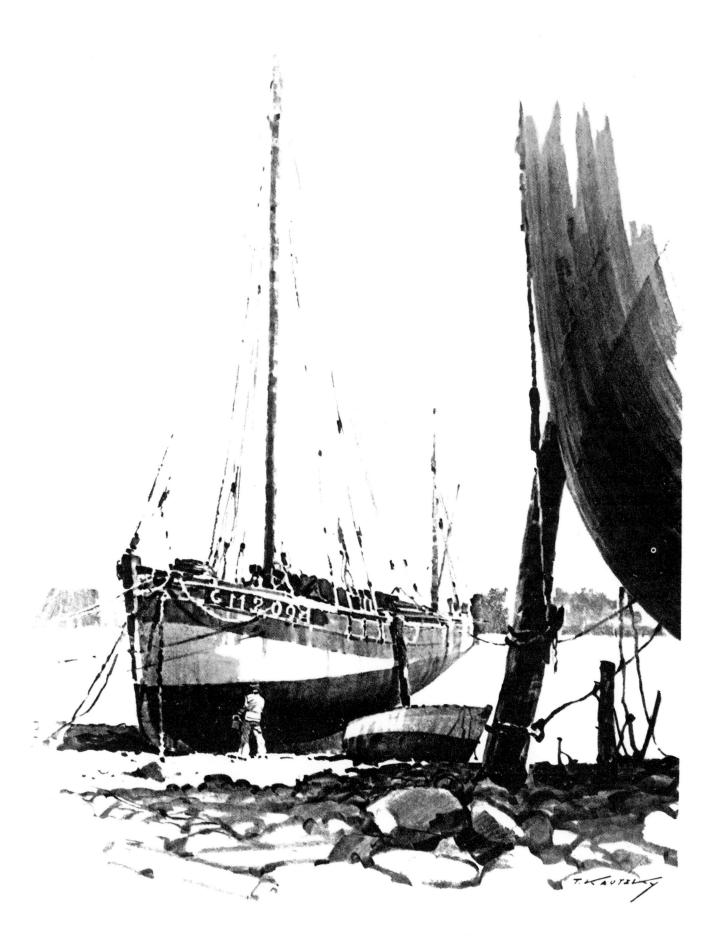

FISHING BOAT, DOUARNENEZ, BRITTANY

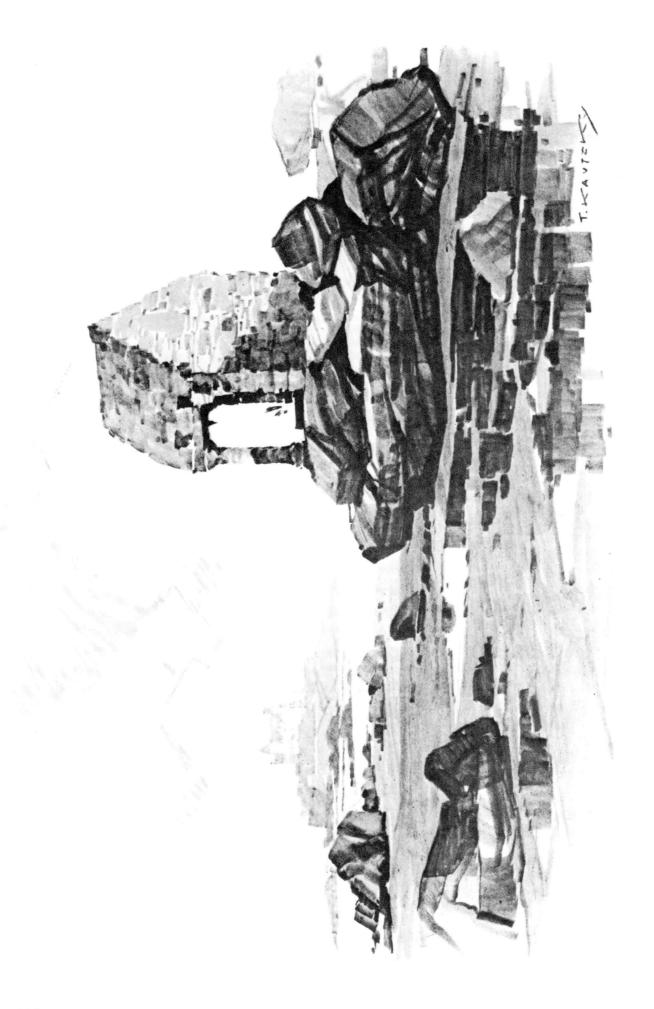

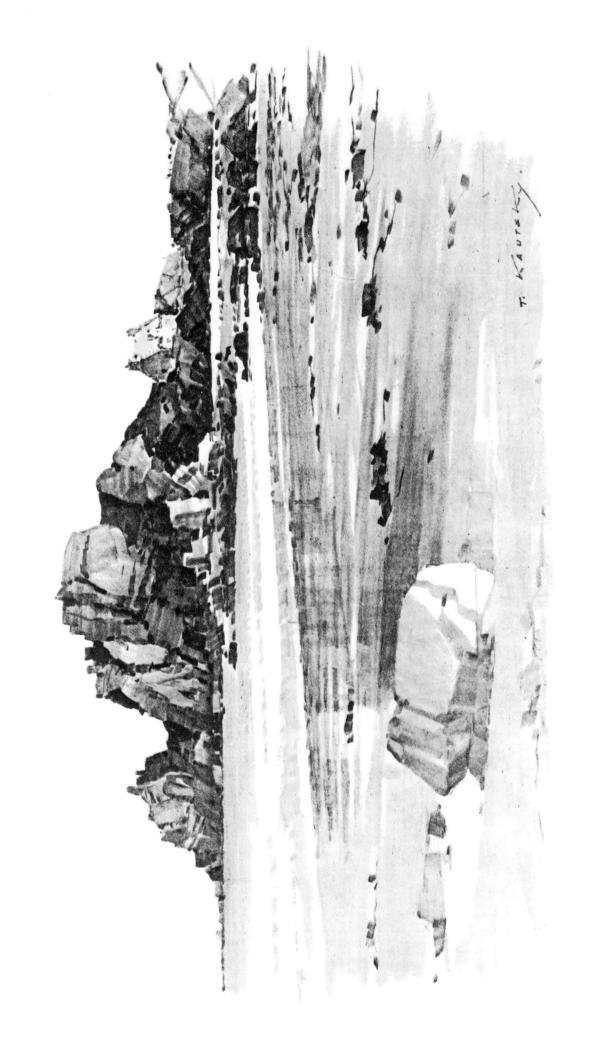

DUTCH COLONIAL

STONE HOUSE, MAINE

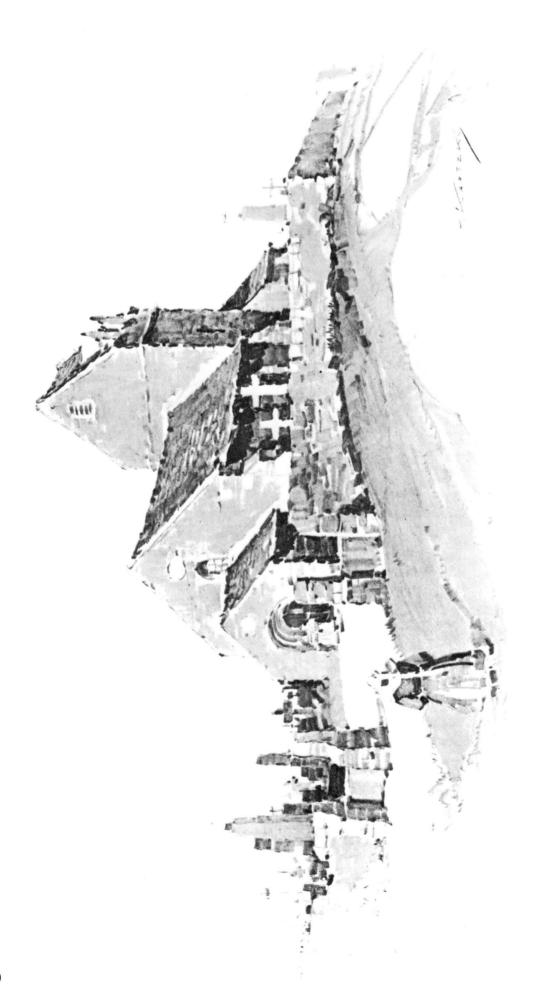